Explorations in ART

Marilyn G. Stewart Eldon Katter

CONTRIBUTING AUTHORS LAURA H. CHAPMAN NANCY WALKUP

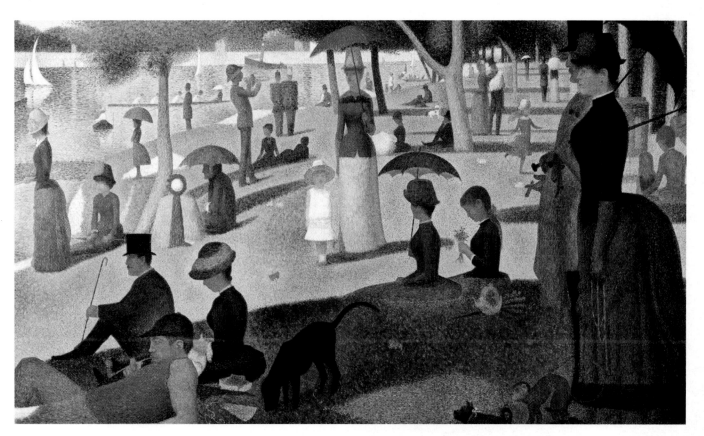

Georges Seurat, *Sunday Afternoon on the Island of La Grande Jatte* (detail).

Davis Publications, Inc. Worcester, Massachusetts

Library of Congress Control Number 2007927337
Printed in the United States of America
ISBN: 978-0-87192-770-5
1 2 3 4 5 6 7 8 9 RRD 14 13 12 11 10 09 08 07

Credits and acknowledgments can be found on pages 198 and 204.

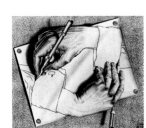

iii

Unit 2 Sharing Stories
Art and Communication

Unit 3 Presenting Places
The Human Landscape

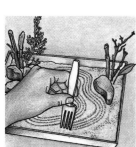

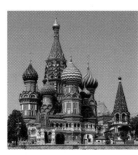

Unit 4 | Nature's Gifts
Making Choices

page

Unit Introduction 92

19 **In the Wild** Emphasis 94
Studio Draw Your Feelings About Animals 95

20 **Animals at Play** Center of Interest 96
Studio Create a Relief Print of an Animal at Play 97

Studio Exploration
Creatures Up Close Collograph 98
Collage printing

21 **The Light of Day** Color Schemes 102
Studio Sketch the Time of Day 103

22 **Looking at the Land** Warm and Cool 104
Studio Draw a Landscape 105

Studio Exploration
Natural Habitats Unity and Variety 106
Crayon resist painting

23 **Tools from Nature** Line Qualities 110
Studio Drawing Lines with Sticks 111

24 **Gifts from Nature** Form and Texture 112
Studio Create a Recycled Paper Bowl 113

Studio Exploration
Containers from the Earth Coil Method 114
Clay construction

Connections Living with Animals 118

Review: Vocabulary and Content 120

Student Handbook

page

What is art?
Art is...

Photography

Painting

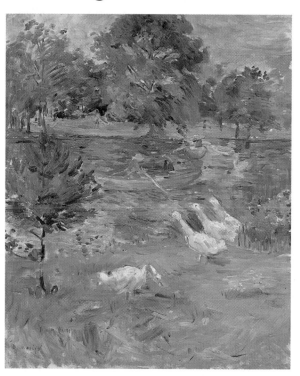

Berthe Morisot, *Girl in a Boat with Geese*, ca. 1889.

Sculpture

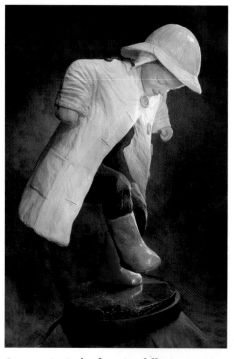

Susan J. Geissler, *Puddle Jumper*, 2005.

Architecture

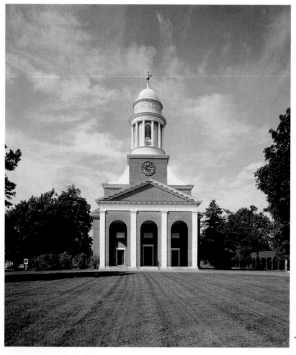

Charles Bulfinch, Church of Christ, 1816.

Clothing

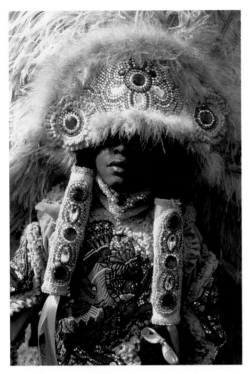

Young Mardi Gras Indian, New Orleans, Louisiana.

Weaving

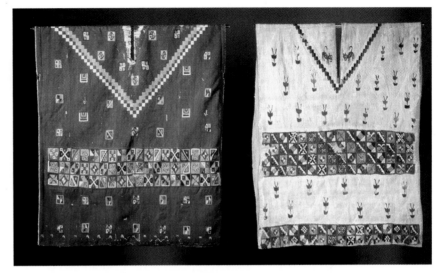

Two Inca Ponchos with Geometric Designs, ca. 1380–1520.

Furniture

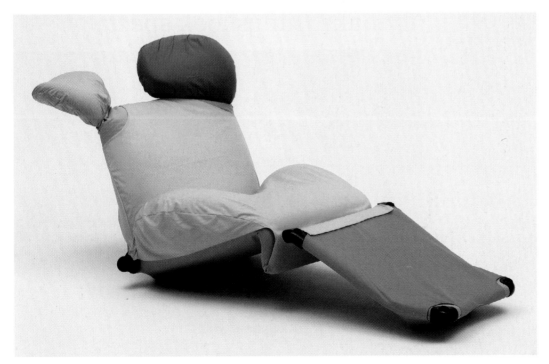

Toshiyuki Kita, *Wink Lounge Chair*, 1980.

People make art. Why?

To share feelings.

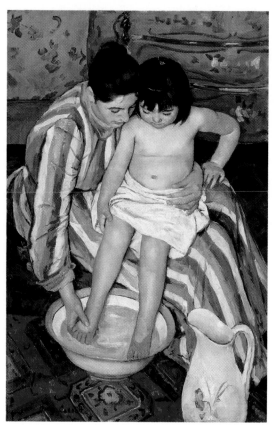

Mary Cassatt, *The Child's Bath*, 1893.

To tell stories.

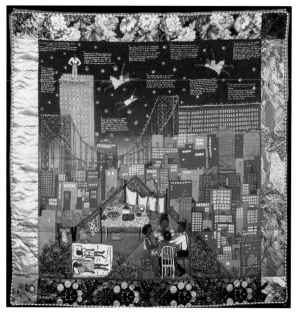

Faith Ringgold, *Tar Beach 2*, 1990.

To make things look special.

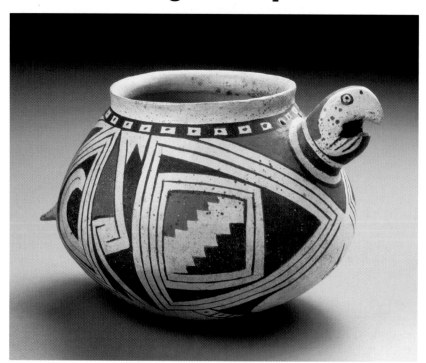

Macaw Bowl, 1300–1350.

To remember special people.

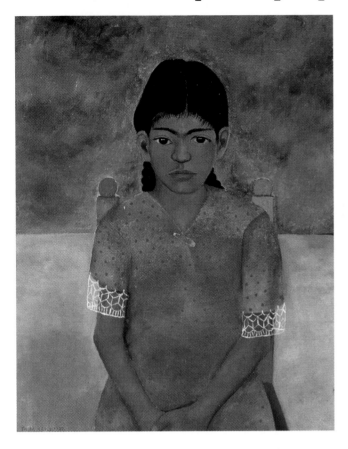

Frida Kahlo, *Portrait of Virginia*, 1929.

To remember special times.

Doris Lee, *Thanksgiving*, ca. 1935.

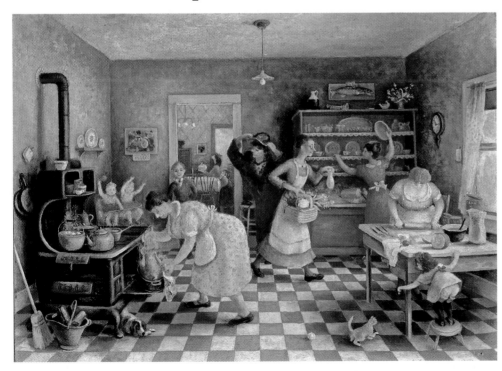

People make art everywhere in the world.

Mexico

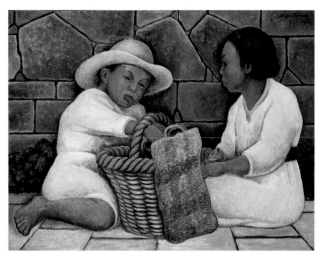

Diego Rivera, *Children at Lunch,* 1935.

Italy

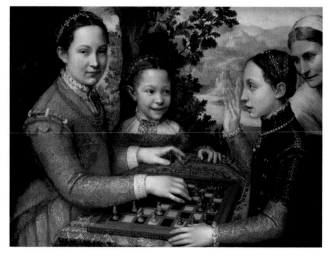

Sofonisba Anguissola, *A Game of Chess,* 1555.

Niger

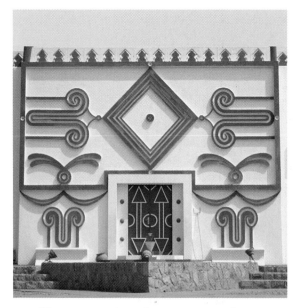

Pavilion at National Museum, Niamey.

India

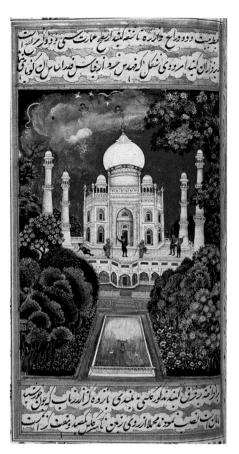

The Taj Mahal at Agra, 1600s.

Egypt

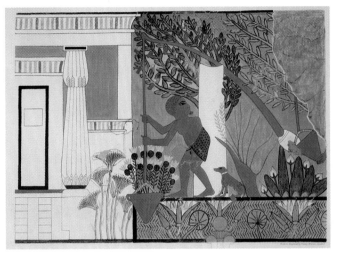

The Watering of Plants in a Garden, 1300–1200 BCE.

Canada

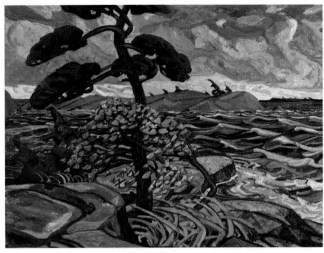

Arthur Lismer, *A September Gale, Georgian Bay*, 1920.

China

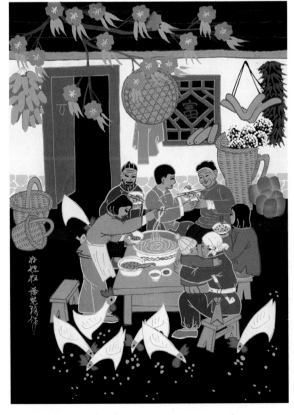

Tempera painting.

Spain

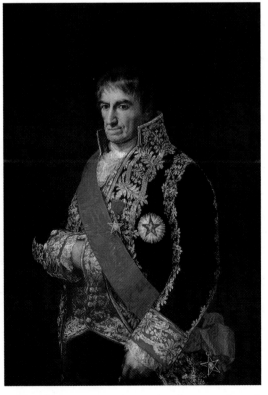

Francisco Goya, *Portrait of General José Manuel Romero*, 1810.

People who make art are called artists. Artists choose their subjects.

Portrait

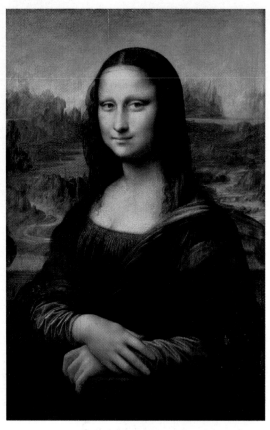

Leonardo da Vinci, *Mona Lisa (La Gioconda)*, 1503–1506.

Still life

Tom Wesselmann, *Still Life #30*.

Landscape

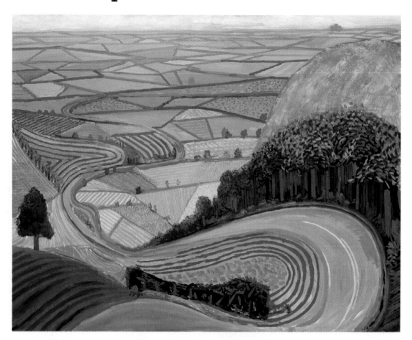

David Hockney, *Garrowby Hill*, 1998.

Artists choose their materials.

Paint

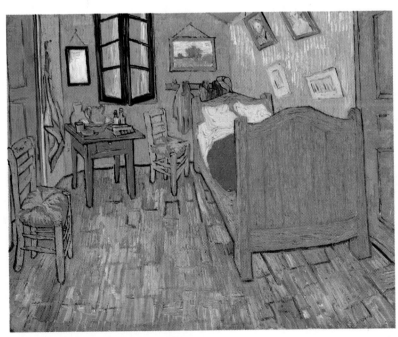

Heinrich Campendonk, *Landscape*, 1917.

Stone

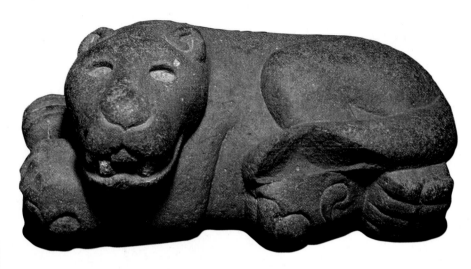

Aztec, *Reclining Jaguar*, 1440–1521.

Artists think about their composition.

What do you see in this painting?

Vincent van Gogh, *The Bedroom*, 1889.

Art is a language. The elements of art are the words of the language.

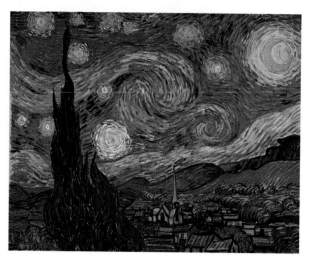

Vincent van Gogh, *The Starry Night*, 1889.

Color

Line

Shape and Space

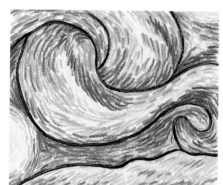

Form

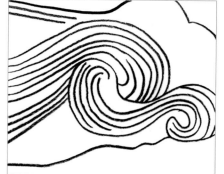

Texture

Value

Artists organize these words using the principles of design.

Pattern

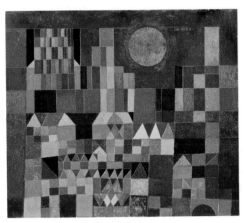

Paul Klee, *Castle and Sun*, 1928.

Movement and Rhythm

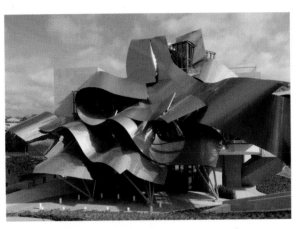

Frank Gehry, *Hotel Marques de Riscal Elciego*, 2006.

Variety and Unity

Proportion

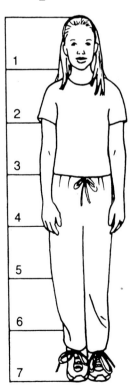

Symmetrical Balance

Art Criticism

Loïs Mailou Jones,
*Coin de la Rue
Medard,* 1947.

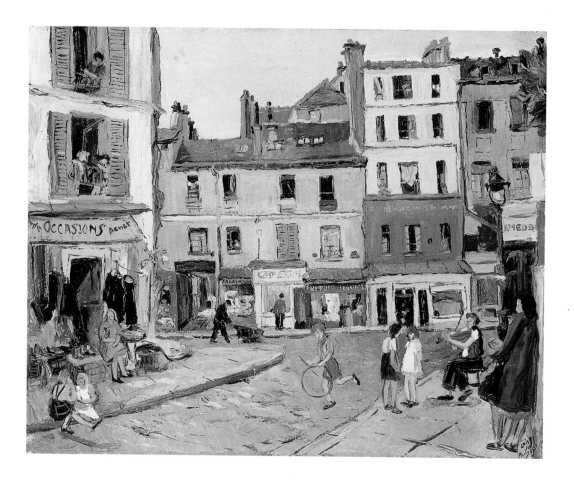

1. We **describe** what we see.
 What do you see in this painting?

2. We **analyze** the painting's organization.
 What details did the artist paint?

3. We **interpret** what the artwork is saying.
 How do you think the artist feels about
 this place?

4. We **evaluate** the artwork.
 What do you like about this artwork?

A 5-Step Process

Step 1 Plan and Practice
We start with an idea.
We practice with
materials and tools.

Step 2 Begin to Create
We begin to try
out our idea.

Step 3 Revise
We make changes.

**Step 4 Add Finishing
Touches**
We add details.

Step 5 Share and Reflect
We share our work with others.
We learn from our work.

Appearances
Looking at Our World

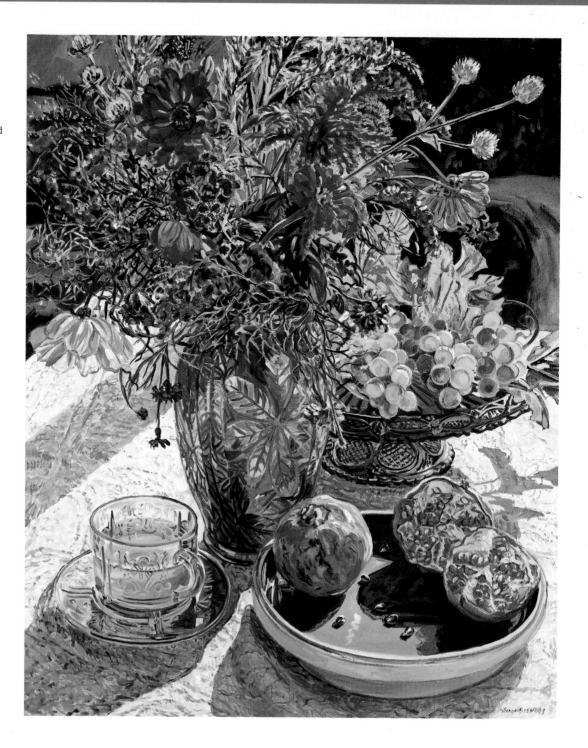

A

Janet Fish, *Green Tea Cup,* 1999. Oil painting.

Art © Janet Fish/Licensed by VAGA, New York, NY.

What lines, shapes, and colors do you see in this still life?

We all notice the appearance of things in the world around us.

We appreciate beautiful objects, attractive buildings, or colorful gardens.

Artists create beauty in the artworks they make. They look for ways to record how things appear.

They look carefully at colors, shapes, lines, textures, and values.

They plan ways to organize these visual elements in their paintings and sculptures.

They explore how things look from near and far and from above and below.

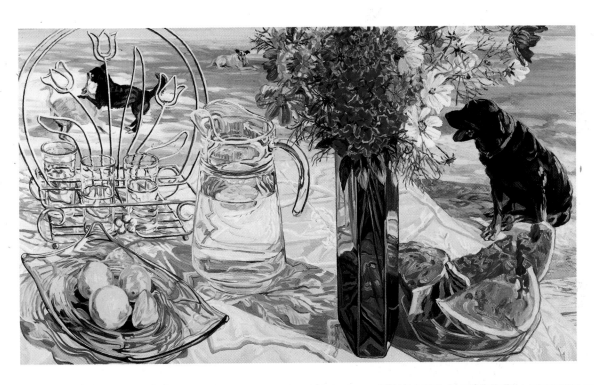

Janet Fish, *Dog Days*, 1993. Oil painting.

Art © Janet Fish/ Licensed by VAGA, New York, NY.

What do you think the artist wants you to notice in this painting?

Meet Janet Fish

Janet Fish spent most of her childhood on the sunny island of Bermuda. As an artist, she looks carefully at the way things appear. Sunlight and reflections of light make her realistic still lifes sparkle. She wants people to pay more attention to the beauty of the objects around them.

Looking Closely

Sometimes artists make sketches to remember and understand what they see.

A sketch can be a drawing without a lot of detail. Some sketches have more details than others.

An artist made the sketches in Ⓐ to prepare for a larger drawing he would use for a painting.

Look at the hands in Ⓑ. What kinds of lines do you see?

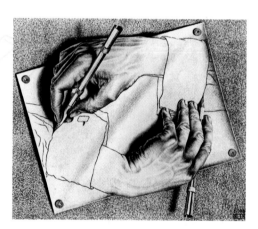

Ⓑ M. C. Escher, *Drawing Hands*, 1948. Lithograph.

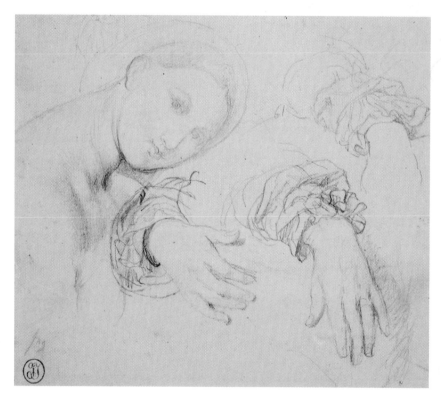

Ⓐ Jean Auguste Dominique Ingres, *Studies*, 1814–1816. Pencil.

The artist made the sketches in **C** to explore some ideas for the painting in **D**.

Can you tell which sketch she used to plan her painting?

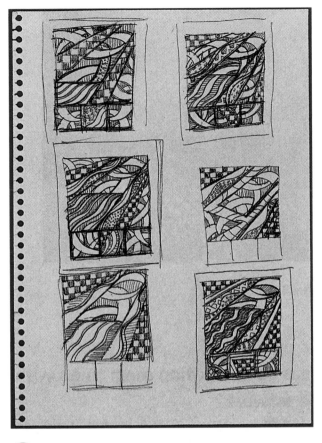

C Patricia A. Renick, sketches for *Spectrum I*, 1991.

D Patricia A. Renick, *Spectrum I*, 1991.

Studio Time

Contour Drawing

A sketch can be a contour drawing. A contour drawing shows the edges or outline of a shape or form.

- Look closely at your hand. Notice how each part is related to other parts.
- Draw slowly and carefully.
- Follow the edges you see.

E

Student artwork

Seeing People

Many artists practice drawing people.

Edgar Degas made the studies of a dancer in 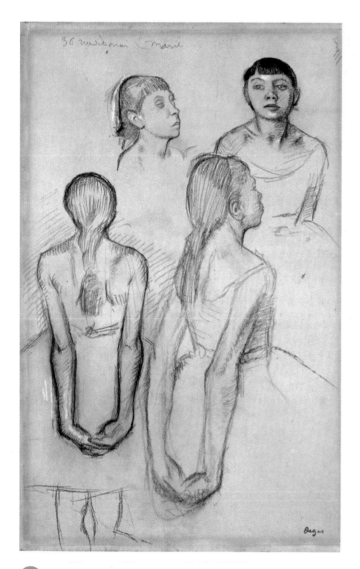A. He often asked dancers to pose so that he could sketch them. A person who poses for an artist is called a model.

Vocabulary

English	Spanish
pose	*posar*
model	*modelo*
proportion	*proporción*
gesture drawing	*dibujo gestual*

Edgar Degas made many sketches of models in different poses before he created the sculpture in B. How are the poses in the sketches similar to that of the finished sculpture?

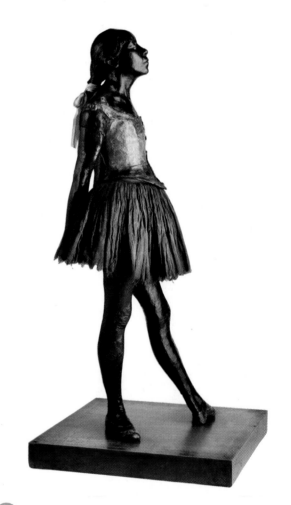

A Edgar Degas, *Four Studies of a Dancer*, 1878–1879. Chalk drawing.

B Edgar Degas, *Little Dancer, Aged Fourteen*, 1878–1881. Bronze sculpture.

The guidelines in **C** can help you see and draw **proportions** in a figure. Proportions show how parts are related to each other. For example, the hips are about halfway between the feet and the top of the head.

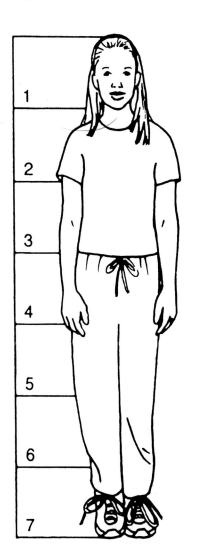

C

Studio Time

Gesture Drawing

Gesture drawing captures the movement or pose of an object or figure.

- You can practice gesture drawing in your class. Some students will be models. They will pose so that everyone can practice drawing.

- Draw quickly. You can add details later if you want.

- Take in the overall action of the pose of your subject.

- Use large, swift strokes to help you capture the forms, angles, and directions.

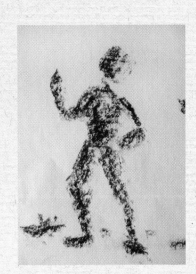

D

Student artwork

Materials you will need
• wire
• wood for base
• stapler or tacks

Line and Movement
Seeing Bodies in Motion

Read, Look, and Learn

What games, sports, and action-packed activities do you like? The pictures on these pages show people in action. The appearance of action comes from the bends in the body. Do you see the angles in the arms, legs, wrists, and ankles?

You can show a figure in action. Choose an activity you like and know about. Sketch some figures with angles that show motion. Then use wire to create a three-dimensional wire sculpture.

Remember to:

✔ Show a figure in action.

✔ Twist wire to make your sculpture sturdy.

✔ Refer to and use guidelines for proportion.

Step 1: Plan and Practice

• Look at the pictures on these pages of people in action.

• Try creating those poses yourself.

• Make some sketches for your sculpture.

• Practice by working with a short piece of wire.

• See how you can shape, bend, curl, and twist it.

Vocabulary

English	Spanish
wire sculpture	*escultura de alambre*

Inspiration from Our World

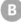 B

Computer Option

Use a drawing program to work with lines. Experiment with the tools that let you change the way a line looks.

Inspiration from Art

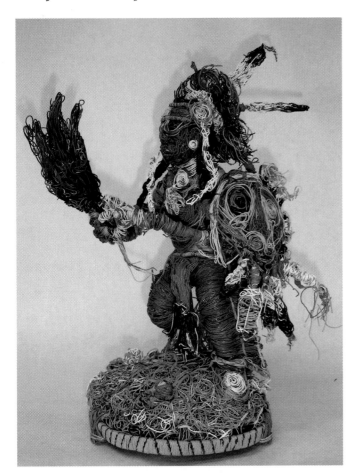

A

Dwight Billedeaux, *Inter-Tribal Internet*. Wire sculpture.

Dwight Billedeaux created this sculpture. What parts of the body are bending? How did the artist show action with wire?

C

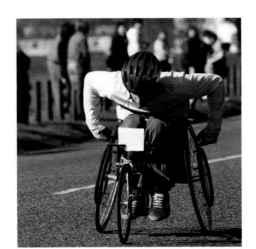

D

Step 2: Begin to Create →

- Gather your materials together.
- Have two pieces of wire. One should be at least 6 feet long and the other should be at least 2 to 3 feet long.

Step 3: Revise

- Are you pleased with the action and pose of your sculpture?
- Did you twist your wire to make your sculpture sturdy?
- Do the proportions look correct?

Step 4: Add Finishing Touches

- Use different kinds of wire to add thickness to your sculpture.
- You may decide to add beads, buttons, or other found materials.
- Pose your figure.
- Attach your sculpture to a wooden base with a stapler or thumbtacks.

Step 5: Share and Reflect

- Arrange completed sculptures in a tabletop display.
- Have a class discussion about your sculptures.
- What action does each figure show?
- If you were going to make a wire sculpture again, what action would you want to show?

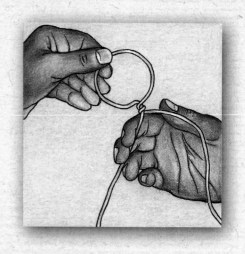

Bend the long piece of wire in half. Twist it to form a head and neck.

Portfolio Tip
Each work in your portfolio should have your name, the title of the work, and the date you completed it.

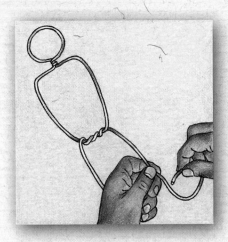

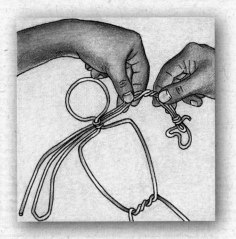

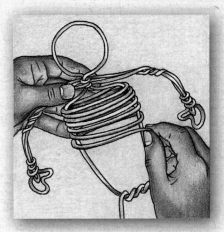

Bend and twist the wire to create the body and legs.

Fold the shorter wire in half. Wrap it around the neck to form arms and hands. Twist for elbows and wrists.

Add additional wire to add thickness to all parts of the figure.

Art Criticism

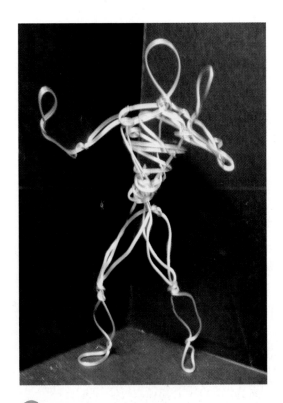

A Student artwork

Describe
What action do you see in this sculpture?
What materials did the artist use?

Analyze
How did the artist pose the figure to show the action?
Where do you see angles?

Interpret
Does the sculpture seem playful?
Why or why not?
What words can you use to describe the sculpture's expression?

Evaluate
Does the sculpture appear to be sturdy?
Why or why not?

Looking at Colors Together

Sometimes artists are inspired by the colors they see. The artists who created the paintings in 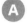 and **B** mixed colors.

Vocabulary

English	Spanish
hue	*tono*
primary colors	*colores primarios*
secondary colors	*colores secundarios*
intermediate colors	*colores intermedios*

B Richard Diebenkorn, *Girl with Plant*, 1960. Oil painting.

A

Beatriz Milhazes, *Succulent Eggplants*, 1996. Synthetic polymer painting.

Let's discuss some ideas about mixing paint colors. The name of a color is its hue.

The common hues are rainbow colors: red, yellow, orange, green, blue, and violet. Picture 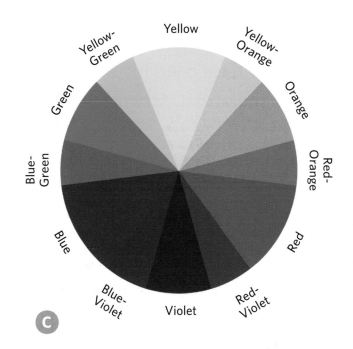 C shows the rainbow hues arranged in a circle, or color wheel.

You can mix many colors from the three primary colors: red, yellow, and blue. Orange, green, and violet are called secondary colors.

Look at the intermediate colors on the color wheel. They have names like blue-violet and blue-green. What are the other intermediate colors?

C

Studio Time

Beautiful Colors

Paint a garden with many colors.

- Plan the parts of your painting and the colors you will use.
- Paint large areas first.
- Allow the first color to dry before painting over an area.

D Student artwork

Seeing Shadows and Light

Many artists have been inspired by the sea or the ocean. Artworks that show a view of the sea or the ocean are called seascapes. The artworks in this lesson show some of the ways artists arrange values, or dark and light colors, to create beauty in seascapes.

Most of the colors you see in (A) are tints. A tint is a light value of a color. You mix a tint by adding a color to white. What tints do you see in this painting?

(A) Henri Edmond Cross, *Coast Near Antibes*, 1891–1892. Oil painting.

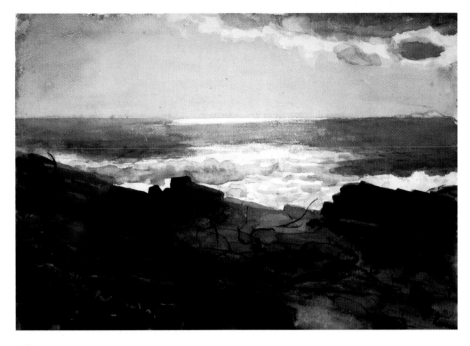

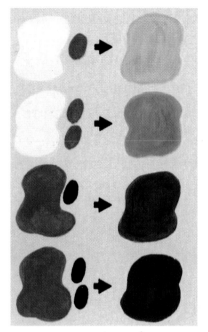

B Winslow Homer, *Sunshine and Shadow, Prout's Neck*, 1894.
 Watercolor painting.

C

The seascape in B has a wide range of values from very dark to very light. In what part of the painting do you see dark values, or shades? A shade is mixed by adding black to a color. Where is the darkest value? The lightest?

Dark and Light Seascape

Think about a real or imaginary seascape. It could be full of action or very calm.

- Plan your painting. How much sky will you show?
- Will the water be choppy or smooth? Will you show any land?
- What tints and shades will you use? Plan values from light to dark.

D Student artwork

Foreground and Background
Seeing Cities

Materials you will need
- colored construction paper
- tissue paper
- scissors
- glue

Read, Look, and Learn

Some artists are fascinated with cities and buildings. Artworks that show groups of large buildings are called cityscapes. Cityscapes can show a range of values from dark to light. An artist can plan a cityscape so that one shape overlaps, or covers part of, another shape.

An artist can group the shapes and values so that your eye moves from foreground to middle ground to background. Foreground shapes seem near to you and the background shapes seem far away.

You can use layers of cut-paper shapes and sheets of white tissue paper to create a cityscape with a foreground, middle ground, and background.

Remember to:

✔ Overlap shapes.

✔ Clearly show foreground, middle ground, and background.

✔ Show a range of values.

Computer Option

Use a drawing program to make a series of boxes, any size. Move the boxes around on the page. Overlap them. See what happens when you order the boxes from small to large.

Step 1: Plan and Practice

- Look at pictures of cities and buildings.
- Think about towns and cities you have seen.
- Look at the pictures on these pages for ideas about buildings that overlap.

Vocabulary

English	Spanish
cityscape	paisaje urbano
overlap	superposición
foreground	primer plano
middle ground	término medio
background	fondo

Inspiration from Our World

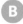

Inspiration from Art

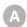

George Copeland Ault, *From Brooklyn Heights*, 1925. Oil painting.

Where do you see dark values in this cityscape? Which buildings appear to be near to you?

Which building seems far away? What did the artist do to show buildings near and far?

What details of the buildings did the artist show?

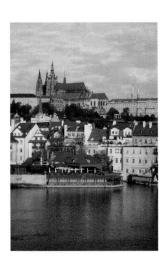

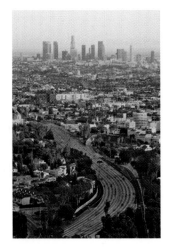

Step 2: Begin to Create ⟶

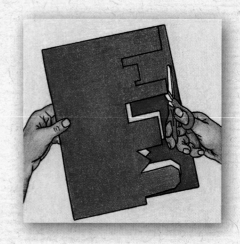

- Start with a light-colored paper.
- This will be your sky.
- Use dark paper for your building shapes.
- A layer of white tissue will make the dark color seem lighter.

Cut buildings out of dark construction paper. Glue these to light paper. Cover with tissue paper and glue.

Step 3: Revise

- Did you overlap shapes?
- Do you show foreground, middle ground, and background?
- Did you create a range of values?

Step 4: Add Finishing Touches

- Does your foreground extend to the bottom of the paper?
- Do you think details such as windows and doorways are needed in the foreground?

Step 5: Share and Reflect

- Ask classmates to identify the foreground, middle ground, and background spaces in your artwork.

Sketchbook Connection

Make a collage of a city in your sketchbook. Cut shapes from different parts of a newspaper or magazine. Sort your shapes from dark to light. How can you arrange them in a scene with a clear foreground, middle ground, and background?

Cut buildings that will be in the middle ground. Glue. Cover with another layer of tissue paper and glue.

Cut shapes for the foreground. Glue these shapes in front of the middle ground buildings.

If you wish, use markers to add details to your foreground.

Art Criticism

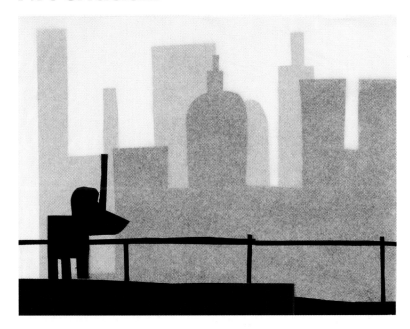

(A) Student artwork

Describe
What kinds of buildings do you see in the artwork?

Analyze
Where do you see dark values? Where do you see light values?

Interpret
Would the title *Moody City* fit with the artwork? Why or why not?

Evaluate
What did the artist do especially well in the artwork? Explain your answer.

Up, Down, and Straight Ahead

Every day you see many views of people, places, and objects. A view is the position of something when you look at it. The shapes and lines of objects and places look different in each view you see. Artists make decisions about how they will view a subject or place. They might view scenes from high on a hill. They might look straight ahead, or they might look up.

Picture Ⓐ is a painting that shows a view of farm fields. Where might the artist have been sitting when he viewed this scene? The painting in Ⓑ shows pipes and tanks in a factory. How is the artist's view in Ⓑ different from the view in Ⓐ?

What kinds of lines and shapes do you see in these pictures?

Ⓐ

Grant Wood, *Landscape*, 1930. Oil painting.

Art © Estate of Grant Wood/ Licensed by VAGA, New York, NY.

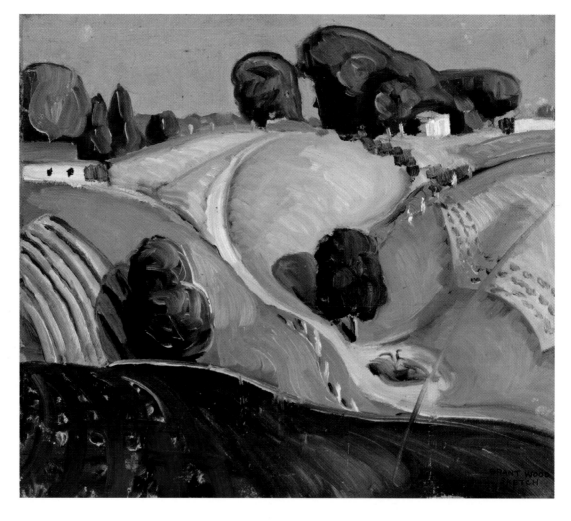

B Charles Sheeler, *Incantation*, 1949. Oil painting

Many of the lines and shapes in Ⓐ have organic, or uneven, curves. Organic lines and shapes remind you of rivers, hills, and other curved things in the natural environment.

Most of the lines and shapes in Ⓑ are geometric. Geometric means the lines and shapes have smooth, even edges. This is true of many buildings and other objects in the human-made environment.

Environments

Create a drawing that shows a specific view of a natural or human-made environment.

- Geometric shapes are good choices for showing the human-made environment.
- Organic shapes usually show the natural environment.
- Overlap shapes. Show details and texture.
- Show light and shadow by layering tints and shades of oil pastels.

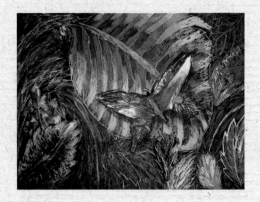

C Student artwork

Vocabulary

English	Spanish
view	*vista*
organic	*orgánico*
natural environment	*ambiente natural*
geometric	*geométrico*
human-made environment	*ambiente artificial*

Looking at Trees

How do artists look at the world around them? Sometimes they look for the main shapes and structures. Often the main shape is similar to a geometric shape.

Vocabulary

English	Spanish
structure	*estructura*
monoprint	*monograbado*

Even natural objects like trees can have geometric shapes. Geometric shapes are shown in the center columns of pictures **A** and **B**. Have you seen trees with shapes similar to these?

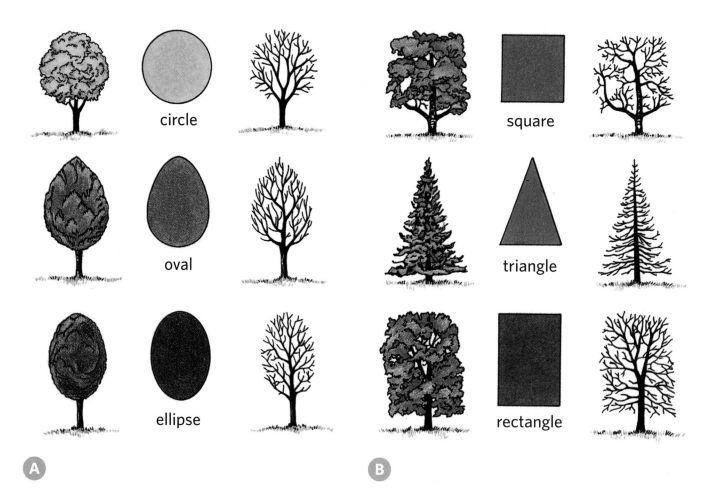

circle

oval

ellipse

square

triangle

rectangle

A

B

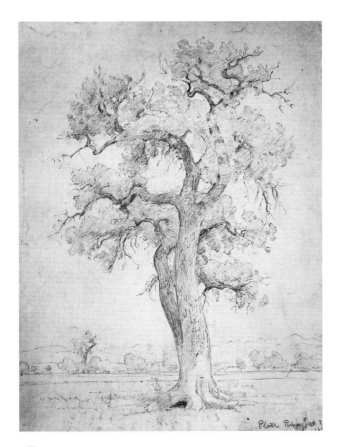

C Thomas Worthington Whittredge,
Study of a Tree, Colorado, 1871. Pencil.

Many forms in nature also have a "skeleton," or structure. You can see the structure of a tree in the trunk and branches. Look at the drawing of a tree in C . In most trees, the trunk is much thicker than the branches. The branches gradually get smaller as they grow upward and outward. Can you see how the artist observed the main shapes and structures of the tree?

Tree Monoprints

Practice drawing trees and other things you see. Then make a monoprint.

- Put paint on a smooth surface like plastic, metal, or waxed paper.
- Paint the main shapes and structure of the tree. Lightly add other colors for details.
- Use tools to draw some lines and wipe away some of the paint to create a natural appearance.
- To make a print, put paper over the whole design. Rub the paper to press it into the paint.
- Lift the paper slowly from one corner. This is called "pulling the print."

D Student artwork

Materials you will need
- paper
- crayon
- brushes of different sizes
- tempera paint

Organizing a Space with Lines and Shapes
Painting a Bird's-Eye View

Read, Look, and Learn

Have you ever flown in an airplane or looked down from the top of a very high hill or tall building? How do you think the land looks to a bird flying above? In this lesson, you will create a painting of a view from the sky. Pretend you're a bird or that you're looking down from an airplane. What kind of scene might you show from high above?

Remember to:

✔ Organize the main shapes and structures.

✔ Show different types of lines and shapes.

✔ Mix colors, tints, and shades.

Step 1: Plan and Practice

- Look at the pictures on these pages for ideas.

- Will you show a natural or human-made environment?

- Where would you have to be to see the view?

- What lines would you see? What geometric and organic shapes would you see?

- Practice with different-sized brushes to see what kinds of lines and shapes you can create.

Inspiration from Our World

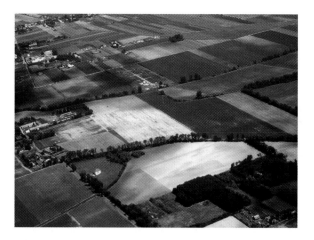

B Aerial view of agricultural fields

24

Inspiration from Art

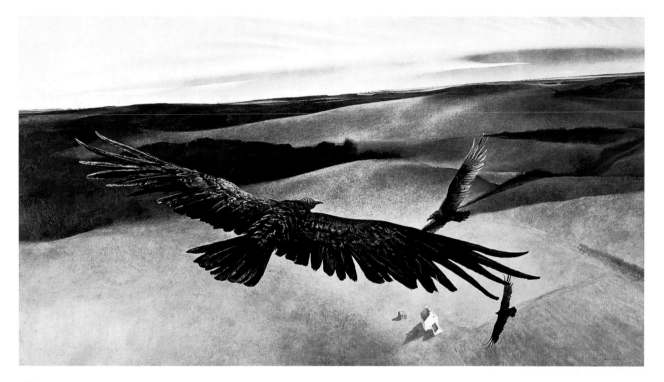

A Andrew Wyeth. *Soaring*, 1942–1950. Tempera painting.

Why are the birds shown in different sizes? Why is the farmhouse so small?
What else did the artist want you to see and feel?

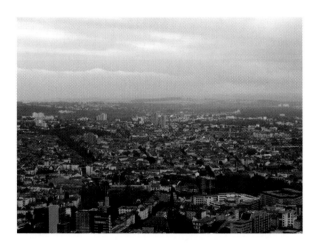

C Aerial view of city and suburbs

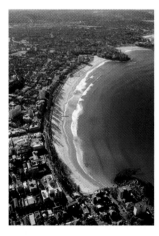

D Aerial view of coastal waterway

Step 2: Begin to Create →

- Position your paper for a tall or a wide picture.
- Sketch your bird's-eye view with crayon on the paper.
- Choose one color to start your painting.

Make a sketch.

Step 3: Revise

- Did you organize the parts of your painting?
- Did you use different types of geometric and organic lines and shapes?
- Are you pleased with your choice of colors?
- Have you mixed tints and shades?

Step 4: Add Finishing Touches

- With a small brush, add more details such as windows, leaves, or grass.
- Could you use color to show different places?
- Could you use lines to help define different areas?

Step 5: Share and Reflect

- Look at your classmates' artwork.
- Do you see different bird's-eye views and a variety of places?
- What did you learn about the kinds of decisions artists have to make?

Portfolio Tip
Always remember to title and sign your artwork. Put the date on the back.

Sketchbook Connection
Use your sketchbook to write notes and draw ideas about changes you would like to make to improve your painting.

Paint the main spaces and shapes first.

Add important texture and details.

Add more details with a small brush.

Art Criticism

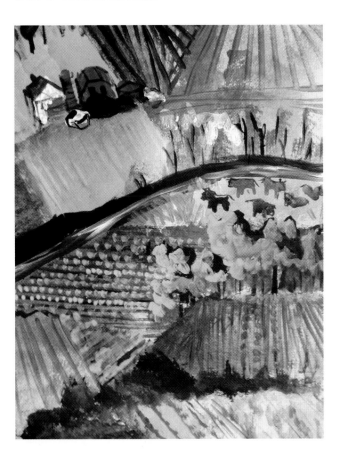

A Student artwork

Describe
What did the artist show in this painting? What colors do you see?

Analyze
How has the artist divided the space in this painting?
Where do you see changes in color and value?

Interpret
How does this country scene seem like a pleasant or beautiful place?

Evaluate
What can you learn about creating a bird's-eye view by looking at this painting?

Appearances
Caring About the Way Things Look

In the Past

This wall painting was created in Egypt more than 3,000 years ago. Only a fragment of the wall remains today. You can still see a pool full of ducks and flowers surrounded by different kinds of trees. What kind of beauty do you think the ancient Egyptians liked to see in their world?

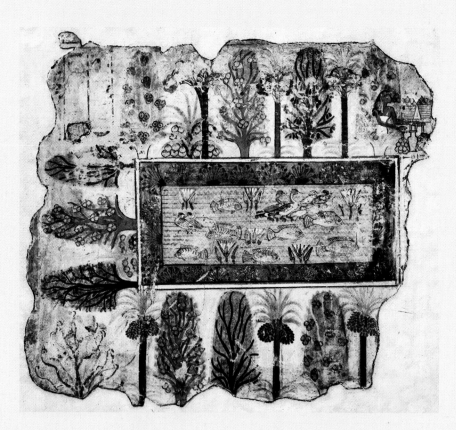

A

Egypt, *A Garden Pool: fragment of a wall painting from the tomb of Nebamun, 1350 BCE.*

In the Past

1350 BCE

1989

In Another Place

Artist Rafael Ferrer was born in **Puerto Rico**. In his paintings, he likes to show the beauty of the islands in the Caribbean. He chooses bright colors and contrasts geometric and organic lines and shapes to show the beauty of life in the islands.

Atlantic Ocean

Puerto Rico

Caribbean Sea

B Rafael Ferrer, *El Sol Asombra*, 1989. Oil painting.

In Daily Life

Betsy Graves Reyneau painted this portrait of George Washington Carver. George Washington Carver was a scientist who liked beautiful flowers. He used his knowledge of science to breed new kinds of flower bulbs.

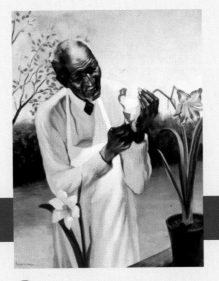

In the Present

C Betsy Graves Reyneau, *Portrait of George Washington Carver*, 1942. Oil painting.

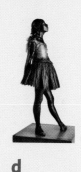

a b c d

Match each phrase to a picture.

1 sketches made as preparation for an artwork
2 a cityscape with foreground, middle ground, and background spaces
3 a sculpture that shows a pose
4 a seascape

Write About Art

Write a six-line poem about this painting. The first line should be the name of the artist. The next three lines should describe the colors, shapes, and lines that you see, in any order you choose. The fifth line should describe the subject matter. The last line should name the title.

Aesthetic Thinking

Should all artworks show things as they appear in the real world? Why or why not?

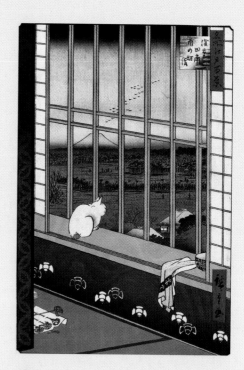

A Ando Hiroshige, *Asakusa Ricefields and Torinomachi Festival, No. 101 from One Hundred Famous Views of Edo*, 1857. Woodblock print.

Art Criticism

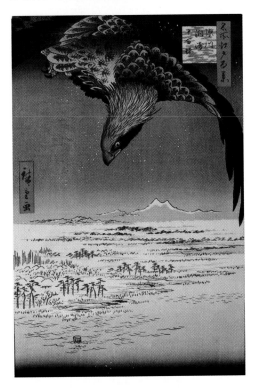

Describe
What do you see in this artwork? What colors did the artist choose?

Analyze
What are the most important elements in this artwork? What do you notice first? Why?

Interpret
What might this artwork tell us about the artist's view of nature?

Evaluate
What do you think this artist could teach you? Why do you think this? Compare this artwork to the other artworks in this unit. How is it different? Do you think this is a beautiful artwork? Why or why not?

B Ando Hiroshige, *Fukagawa Susaki and Jumantsubo, No. 107* from *One Hundred Famous Views of Edo*, 1857. Wood and paper.

Meet Ando Hiroshige

Ando Hiroshige (1797–1858) was born in Tokyo, Japan. He began taking art lessons when he was about 10 years old. He became an apprentice with a master artist at age 15. He became one of Japan's most successful landscape artists.

Art History and Culture
From 1641 to 1853 Japan restricted its interaction with other countries. In this way ancient traditions were preserved.

Sharing Stories
Art and Communication

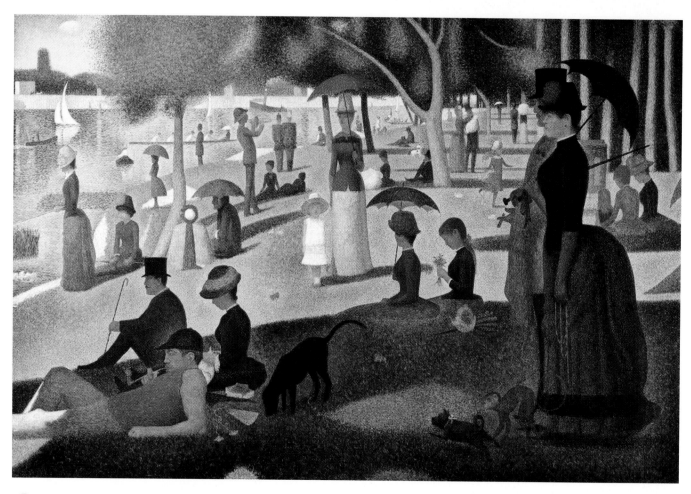

Ⓐ Georges Seurat, *A Sunday Afternoon on La Grande Jatte—1884*, 1884–1886. Oil painting.

What different things are people doing in this painting?

Georges Seurat, *Port-en-Bessin,* 1888. Oil painting.

Where has the artist used tints and shades in this painting?

Most people like to get together with friends and talk. We have fun when we tell stories about things that happen in our lives. Sometimes we share serious ideas; other times we share funny stories. Most often, we communicate with words.

Art is another way to communicate. Artists share ideas in the artworks they make. Their ideas can also be serious or funny. We can look at drawings, paintings, and sculptures for the ideas and stories they tell.

An artist's ideas or stories can be about people, but they can also be about places, animals, or objects. Some artists are interested in communicating with both words and pictures.

Meet Georges Seurat

Georges Seurat was very interested in how people see color. He tried different ways of painting. Instead of mixing colors before using them, he placed tiny dots of different colors of paint next to each other. From a distance, the dots would seem to blend together and appear as one color. This technique is called pointillism.

Face-to-Face

Sometimes artists create portraits. A portrait is a likeness of a real person.

Frida Kahlo, an artist from Mexico, painted the portrait in **A**. The little girl is her relative. What details did the artist show?

Photography is another way for artists to make portraits. Look at **B**. Solomon Getachew, a portrait photographer in Ethiopia, used a camera to create this photograph of his son.

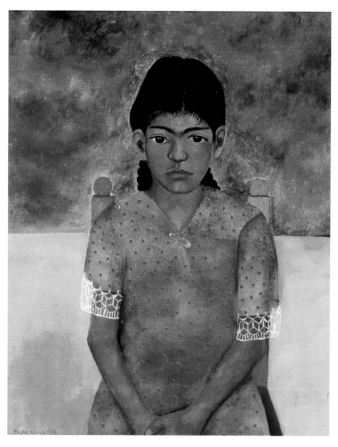

A Frida Kahlo, *Portrait of Virginia*, 1929. Oil painting.

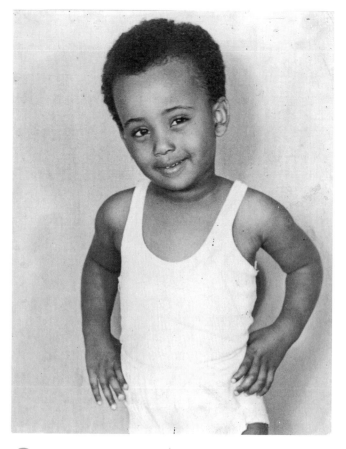

B Solomon Getachew, *That's My Boy*, 1962. Photograph.

Look at picture . The guidelines can help you see and draw the proportions of a face. For example, the eyes are about halfway between the top of the head and the chin.

C

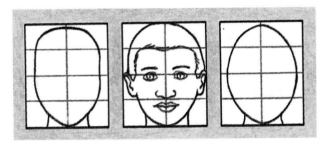

D

Seeing Proportions

Draw a classmate.

Fold your paper as in C. The folds will be guidelines for drawing.

Sit across from your classmate. Observe and draw the shape of the head. Leave space near the edge of the paper to add the ears, hair, and neck as in D.

Draw the eyes, nose, and other features near your guidelines. Look closely and draw the shapes and details you see.

Ask your classmate about his or her favorite things. Create symbols for a border.

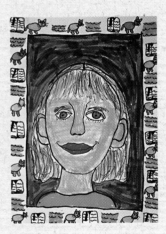

E

Student artwork

Telling Stories

Some artists create history paintings, or paintings that tell about things that happened in the past. John Trumbull painted the scene in Ⓐ to remind people of an important event. It shows the presentation of the Declaration of Independence to the Congress.

To prepare for the painting, the artist made sketches of the individuals and the room. What do you see in the foreground? What do you see in the background?

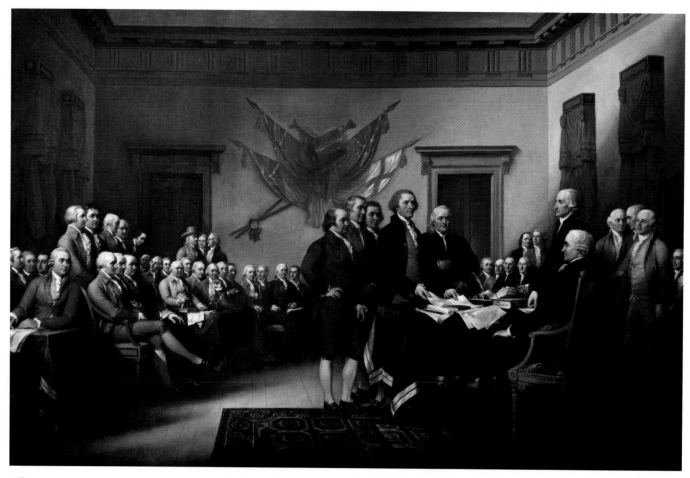

Ⓐ John Trumbull, *Declaration of Independence*, 1817. Oil painting.

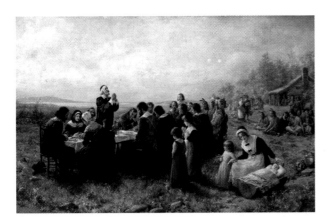

B Jennie A. Brownscombe, *The First Thanksgiving at Plymouth*, 1914. Oil painting.

About 300 years after English settlers formed a colony in Massachusetts, Jennie Brownscombe painted the scene in Ⓑ to share her ideas about the first Thanksgiving. Where do you see shapes that overlap?

About the Artist

Jennie A. Brownscombe was born in a log cabin in Pennsylvania. As a child she loved to draw and write poetry. She became a skillful illustrator and painter. She was known for her scenes of early American history.

Studio Time

What's the Story?

Observe four or five people posed in a group. Plan a picture that shows these people in a crowded place. Make your drawing tell a story.

- Use a pencil to make contour drawings. How will you show people in the foreground? How will you show people in the background?

- What will your story be? Where will it take place?

- Use markers and colored pencils to add color and details to your drawing.

C Student artwork

Clay Sculpture
Sculptures That Tell Stories

Materials you will need
- clay
- clay tools
- acrylic paint
- brushes

Read, Look, and Learn

Many cultures have a tradition of storytelling. As a way of honoring the tradition of storytelling in her Native American culture, Helen Cordero began making clay sculptures of storytellers.

Many other native artists in North and South America have made sculptures about storytellers. The sculptures usually show a seated, open-mouthed adult surrounded by listening children. The children are often shown in different positions.

You can use clay to make a sculpture of a person. You can put your sculpture with sculptures made by your classmates to tell a story.

Remember to:

✔ Show a figure sitting, standing, or reclining.

✔ Bend the arms and legs to show what the person is doing.

✔ Make all parts of your sculpture smooth.

Vocabulary

English	Spanish
sculpture	*escultura*

Step 1: Plan and Practice

- Look at pictures **B**, **C**, and **D** for ideas about poses or actions that tell a story.

- Observe people around you.

- Make some sketches for the sculpture you want to make.

- Will your sculpture show a person reading a book? Sitting on the floor? Singing a song?

Inspiration from Our World

B

Inspiration from Art

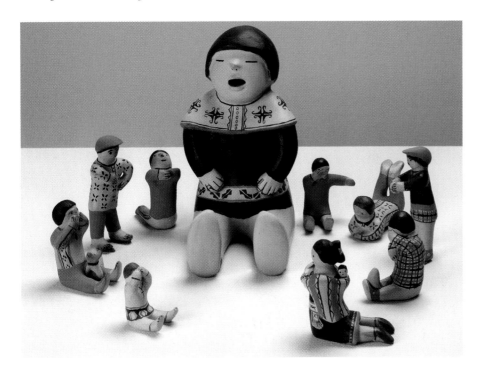

A Helen Cordero, *Storyteller and Children*, 1980. Ceramic.

How can you tell that this is a storyteller sculpture? How are the poses or positions different in each figure? What details do you see?

C

D

Step 2: Begin to Create ———————→

- You can start your sculpture in one of two ways: you can assemble it from parts, or you can shape it from one piece of clay.

- Start with the main form.

- Then add details.

- If you add pieces of clay to your sculpture, join the pieces with a solution of clay mixed with water to make a kind of glue.

Sculpture can be assembled from parts.

Step 3: Revise

- Are you pleased with the position or pose of your sculpture?

- Did you bend the arms and legs to show what the person is doing?

- Did you smooth the clay?

Step 4: Add Finishing Touches

- How will you finish your sculpture after it has dried or been fired?

- You might paint it with watercolor or acrylic paint.

- Perhaps you can glaze it and fire it a second time.

- If you were going to make another sculpture like this, what would you do differently?

Step 5: Share and Reflect

- Display your sculpture with those of your classmates.

- Compare and contrast the poses.

- How can you group your sculptures to tell one or more stories?

Portfolio Tip
You can paint patterns on dry clay. What visual effect will patterns have? What visual effect will solid colors have?

Or, you can pinch or pull a piece of solid clay to create a head and other parts.

Bend arms and legs to pose your sculpture of a person.

Add details and smooth the clay.

Art Criticism

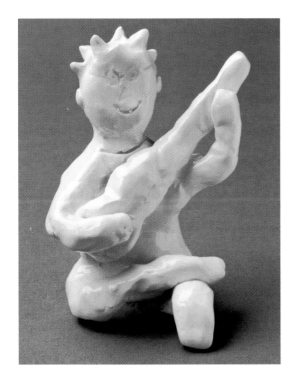

A Student artwork

Describe
What is the clay figure doing? What else did the artist show?

Analyze
What do you see first when you look at the sculpture?

Interpret
What mood or feeling does the artwork seem to express? Why?

Evaluate
What do you think the artist did especially well?

Inventive Communication

Vocabulary

English	Spanish
inventive	*inventivo*
lettering	*leyenda*

Robert Indiana is an artist who likes to be inventive with letters of the alphabet. If you are inventive, you have ideas no one else has thought about. What letters do you see in 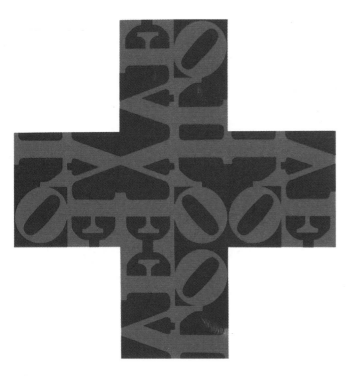?

Some artists invent new kinds of alphabets. They might change letters to look like animals. Do you think the alphabet in **B** is inventive? What do all of these objects have in common?

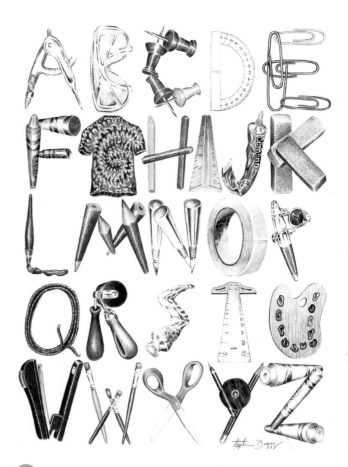

A Robert Indiana, *Love Crosses*, 1968. Serigraph.

B Stephen Buggy, *Art Tool Alphabet*, 2005.

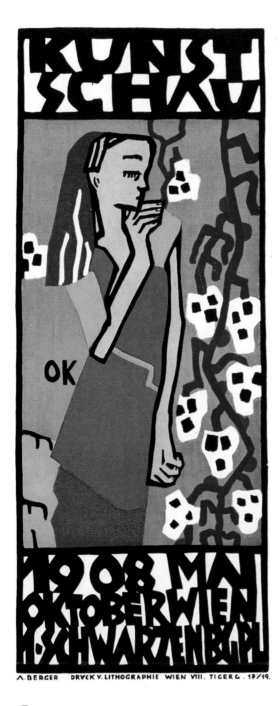

C Oskar Kokoschka, *Art Show Poster*, 1908.

Some artists are graphic designers. They plan the lines, colors, shapes, and lettering on things like posters, billboards, and cereal boxes. What lines do you notice in the poster shown in C ?

Name Stories

Design a story illustration using the letters of your name. Let the shapes of the letters, and the spaces between the letters, give you ideas for the picture you create.

- Draw the letters of your name with markers. Be inventive.
- Think of the spaces between the letters and of what they can add to your story.
- You can change each letter and space by adding pattern and other details.

D Student artwork

Playful Messages

Vocabulary

English Spanish

visual symbol *símbolo visual*

When you communicate, you share ideas with other people. Long before people invented writing, they communicated by making pictures. They sent and received "wordless" messages.

Today, we still communicate without words. One way we communicate through art is to use visual symbols. A visual symbol is made of lines, colors, and shapes that stand for something else. For example, flags are symbols for countries. "Uncle Sam" is a symbol for the government of the United States. What symbols do you see in **A** and **B**?

What do the colors communicate?

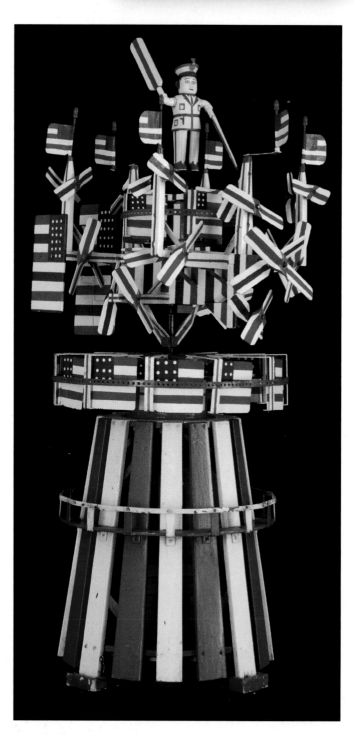

A Frank Memkus, Whirlygig entitled *America*, 1938–1942. Painted wood and metal.

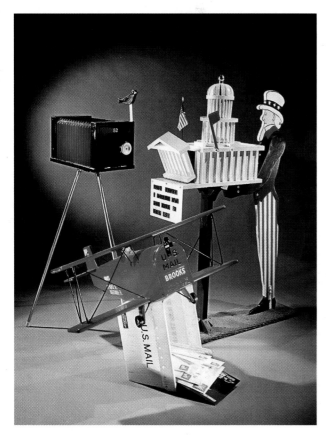

B Folk art mailboxes.

Something's Fishy

You can send a playful message. You can design an unusual visual symbol. You can draw an imaginary fish that matches its name. For example, a sunfish is a real fish, but can you imagine a funny way to draw it? What pictures would you combine to show the word "sunfish"? Here are some other names of real fish:

candlefish	*roosterfish*
goatfish	*torpedofish*
dogfish	*catfish*
guitarfish	*toadfish*
sawfish	*dragonfish*
rabbitfish	*rockfish*

- Use these names to help you get ideas for an imaginary fish.
- Draw the main shape of the imaginary fish quite large.
- Gradually add more details.
- Show where your fish might live.
- Show what it likes to do.

C Student artwork

Materials you will need
- large white paper
- choice of drawing media (markers, colored pencils, oil pastels)
- assorted papers
- old magazines
- scissors
- glue or glue sticks

Collage

Play on Words

Read, Look, and Learn

Some artists find humor in idioms. Idioms are common expressions that don't mean exactly what the words say. For example, when people say, "It's raining cats and dogs," what they really mean is that it's raining hard. They don't mean that cats and dogs are falling from the sky.

If we made a humorous picture of the idiom, "He had to eat crow," the person would be eating an actual crow. In picture **A**, the artist played with this expression even more by showing "eating crow" as a crow eating, not as a person eating a crow.

You can make a collage to go with an idiom.

Remember to:

✔ Be inventive.

✔ Show humor.

✔ Repeat colors and shapes. Fill the paper.

Step 1: Plan and Practice

- Look at the pictures on these pages for ideas.

- Brainstorm with your classmates to identify other idioms.

- Select one and make some sketches.

- Plan the main parts of your picture.

Inspiration from Our World

B Singing like an angel

Inspiration from Art

 Anne Coe, *Eating Crow*, 2006. Acrylic painting.

Anne Coe made a humorous picture to match an idiom. Where do you see repeated colors? Where do you see repeated shapes? Why did the artist show the crows with bandits' masks?

C Faster than a speeding bullet

D Needle in a haystack

Step 2: Begin to Create ———————➤

- Collect shapes from different papers and magazines.
- Remember to plan for large areas of your picture as well as for small areas.

Select an idiom and make sketches.

Step 3: Revise

- Have you made an inventive collage?
- Ask classmates if they see humor in your collage.
- Were you able to fill your paper with repeated colors and shapes?

Step 4: Add Finishing Touches

- Do you need to add details?
- Will you use markers, colored pencils, or oil pastels?
- Make sure you have filled your paper.

Step 5: Share and Reflect

- Display your collage with those of your classmates.
- Play a game in which you try to match pictures with idioms.
- If you chose to create another picture to match an idiom, would you change the way you work?

Sketchbook Connection
Practice drawing cartoon figures to show humor. A cartoon animal or person usually has an exaggerated feature.

Portfolio Tip
Remember to write the idiom you illustrated on the back of your artwork.

Collect shapes from different papers and magazines.

Arrange and glue your large and small paper shapes in place.

Add details with markers, colored pencils, or oil pastels.

Art Criticism

A Student artwork

Describe
What do you see?

Analyze
What colors and shapes did the artist repeat?

Interpret
How did the artist show humor in the artwork?

Evaluate
How successful was the artist in illustrating the idiom "In one ear and out the other"?

Animal Absurdity

Vocabulary

English — caricature
Spanish — *caricatura*

Have you ever seen a bull and an antelope dressed in shirts and jackets and sitting at a table? If you are thinking like a scientist, your answer would be no.

If you are thinking like an artist, your answer might be yes. Many people enjoy stories and cartoons that show animals acting like people.

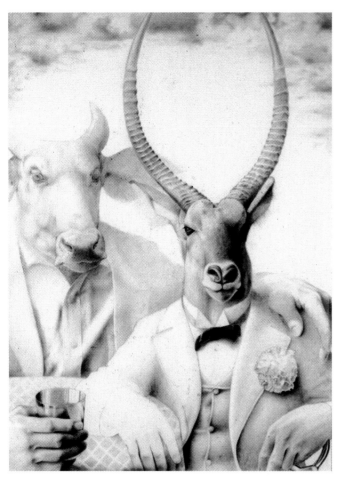

A Peter Traugott, *Corner Table*, pencil.

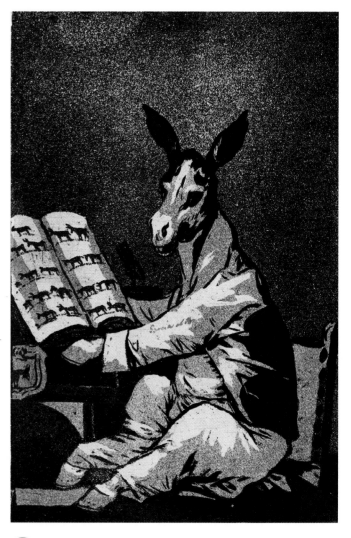

B Francisco Goya, *Los Caprichos #39: And So Was His Grandfather*, 1797–1798. Sketch.

Cartoon-like pictures of animals have been found in many lands. The animals in (A) and (B) are examples of caricature. In caricature, you see a likeness of something, but parts are changed.

What parts of the animals have been changed to make them more like people?

Studio Time

Animal Humor

Create a caricature of an animal. Show an animal doing something that only people can really do. For example, you might draw a dog riding a bike or driving a car. You might draw a fish eating an ice cream cone.

- Make some sketches of an animal.

- Change the animal's parts to make it a caricature.

- Use pencils, markers, or crayons to draw the caricature in a humorous situation.

C Student artwork

Animated Stories

Cartoons in films and television are made from thousands of pictures. Each picture is just a little different from the others. When the pictures are shown very quickly, you see the illusion of movement. What changes help to suggest movement in 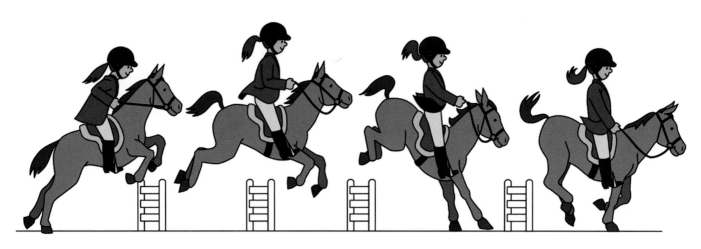?

A

Jim McNeill,
Jumper,
2006. Digital
illustration.

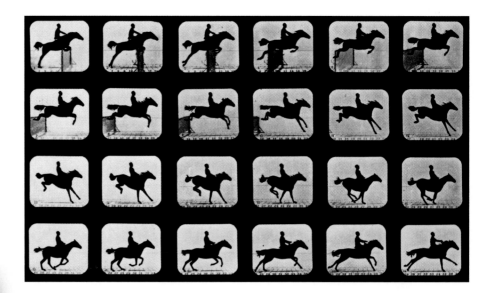

B Eadweard Muybridge, *Muybridge's Horse*, 1881.
Series of photographs.

Vocabulary

English	Spanish
animation	*animación*
animator	*animador*
illusion	*ilusión*

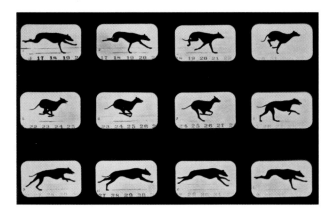

C Eadweard Muybridge, *Muybridge's Dogs*, 1881. Series of photographs.

The art of creating cartoons for films and television is called animation. An animator is an artist who helps draw the cartoons. An animated show is often planned by making flipbooks. A flipbook is a booklet containing a series of images that, when you thumb through them quickly, give the illusion of movement.

Flipbook Movie

You can make a flipbook. Think of something that moves and how it moves.

- Use five index cards.
- On the first card, draw the beginning of the motion. On the last card, draw the end of the motion. Use the center card to draw the middle of the motion.
- Finish the other two cards. These cards will show small changes in the motion.
- Stack your cards in order. Hold them tightly in one hand.
- With the thumb of your other hand, flip the cards from the top to the bottom.
- You can also restack the cards and flip them from the bottom to the top.

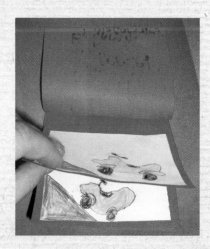

D Student artwork

Moving Pictures
Zoetrope Toys

Materials you will need
- black poster board
- black construction paper
- white drawing paper
- pencil
- markers or colored pencils
- scissors
- tape
- push-pin or thumbtack

Read, Look, and Learn

Most people like to watch movies, or motion pictures. We sometimes forget that a movie is made up of thousands of still pictures. The still pictures are joined together and shown at high speed, one after another. In most cartoon movies, each still picture is a drawing.

In other motion pictures, each still picture is a photograph. Every picture is slightly different from the one that came before it. Before the invention of movies, people tried different ways to create the illusion of movement. A zoetrope is a kind of toy in which simple drawings appear to be moving. You can make your own zoetrope.

Remember to:

✔ Show movement.

✔ Show some kind of activity.

✔ Make small changes from one picture to the next.

Vocabulary

English	Spanish
zoetrope	zootropo

Step 1: Plan and Practice

- Think of an animal, person, or vehicle that you like to draw.

- What activity can you have it do?

- Look at the pictures on these pages for ideas.

- Make some sketches to help you complete your idea.

Inspiration from Our World

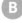 B

Inspiration from Art

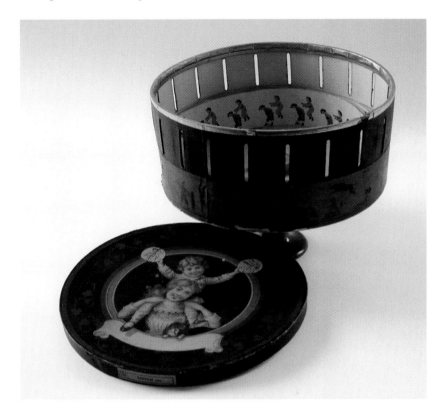

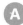

Zoetrope

This shows a zoetrope made over 100 years ago and used as a toy by both children and adults. People looked through the slots as the zoetrope spun around.

The zoetrope was called the "Wheel of Life." Can you imagine why?

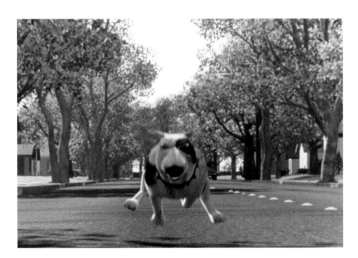

C

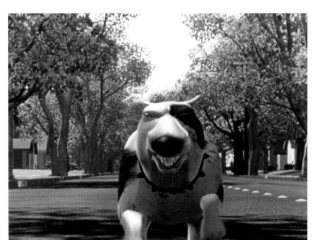

D

Step 2: Begin to Create ———————————————→

- Cut your zoetrope strip to the right length.
- Divide your strip into equal spaces.
- Draw your animal, person, or vehicle in each space.
- Make each drawing slightly different from the one that came before it.

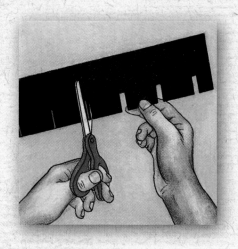

Make even marks. Cut slits at the marks.

Step 3: Revise

- Have you shown an activity?
- Does the zoetrope show movement?
- Do you need to change any of your drawings?

Step 4: Add Finishing Touches

- What details do you need to add?
- Make sure that all parts of your zoetrope are firmly attached.

Step 5: Share and Reflect

- Exchange zoetrope strips with your classmates.
- What kinds of actions did your classmates show?
- How is your strip different from those of your classmates?
- What other strips would you want to make if you did this again?

Sketchbook Connection

Collect pictures from magazines of all types of vehicles. How are they powered? How do they change as they move?

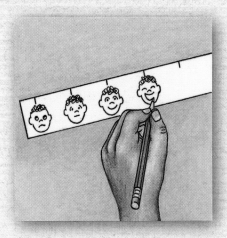

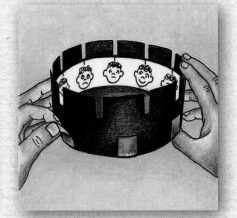

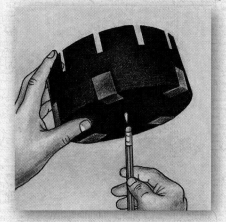

Make the same marks on a new paper. Make drawings underneath the marks that show movement.

Tape the ends together and attach the strip to a circle.

Thumbtack the center of the base to a pencil eraser and spin!

Art Criticism

(A) Student artwork

Describe
What do you see in the completed zoetrope strip?

Analyze
What small changes were made in each separate drawing?

Interpret
What action will you see when the strip is put in the zoetrope?

Evaluate
What did the artists do especially well in making the zoetropes?

Sharing Stories
People Past and Present

In the Past

This picture shows part of a much larger artwork created about 2,000 years ago in Rome, Italy. The Roman emperor Trajan asked the artist to make a sculpture to show other people that he was a great leader. This part of the sculpture shows Trajan speaking to his people about his victory in a battle.

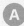

Apollodorus of Damascus, *Column of Trajan, Trajan Addressing his Troops*, 106–113 CE. Marble.

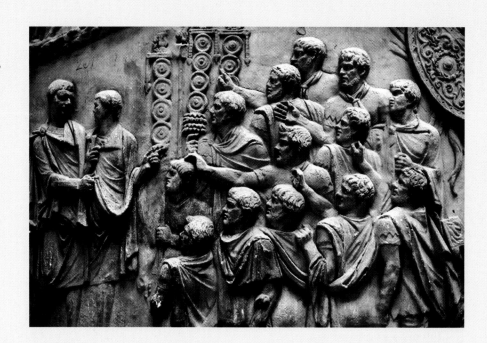

In the Past

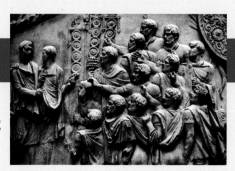

106–113 CE

ca. 1900

In Another Place

People in **China** have a very long tradition of honoring and respecting their ancestors. Artists created portraits of ancestors for families to display in their homes. This portrait shows many generations of one family's male ancestors. It was created in the late 1800s or early 1900s.

China

Pacific
Ocean

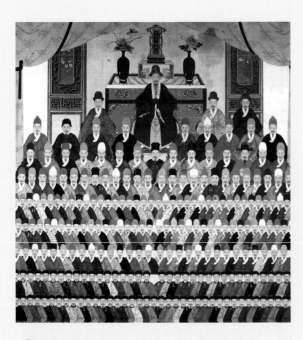

B China, unknown artist. *Multi-Generation Ancestor Portrait.* ca. 1900. Ink and color.

In Daily Life

Some people are fortunate to know their grandparents. Some people know their great-grandparents. When families get together, they often take pictures of all the relatives together as a kind of family story.

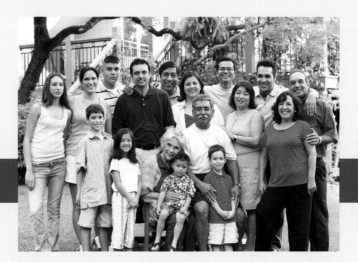

C

In the Present

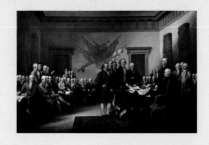
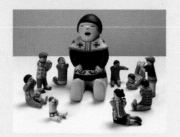
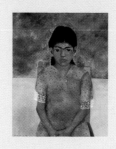

a b c d

Match each phrase to a picture.

1 a traditional Native American sculpture about a storyteller
2 an artwork that tells a story with moving pictures
3 a history painting
4 a portrait

Write About Art

Käthe Kollwitz drew this self-portrait showing herself working at an easel. Write an acrostic poem using the letters of her first name— K, A, T, H, E—to begin each line of the poem. All the lines of the poem should relate to or describe the self-portrait. You can use Käthe's full name to begin the first line of the poem. You can brainstorm words, write, and revise your poem.

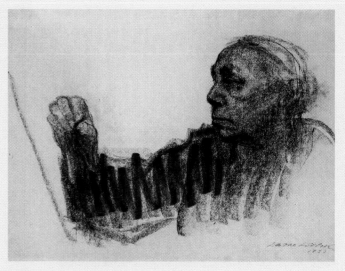

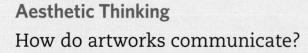 Käthe Kollwitz, *Self portrait Drawing*, 1933. Charcoal.

Aesthetic Thinking

How do artworks communicate?

Art Criticism

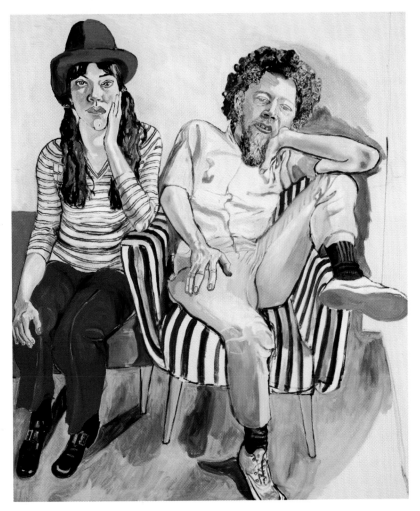

B Alice Neel, *Benny and Mary Ellen Andrews*, 1972.
Oil painting.

Describe
Tell about the people shown in this painting. How are they seated? What are they wearing? What kind of expressions do you see on their faces?

Analyze
What mood or feeling does the artist communicate in this double portrait?

Interpret
What do you think the artist thought about the people? Explain your answer.

Evaluate
Would you want the artist, Alice Neel, to paint a portrait of you and your friend? Why or why not?

Meet Alice Neel

Alice Neel is a portrait painter. Her portraits show people of all different ages. Sometimes she shows them alone and other times she shows them with their friends or family. Alice always chooses the people she wants to paint and tries to share her ideas about them.

Presenting Places
The Human Landscape

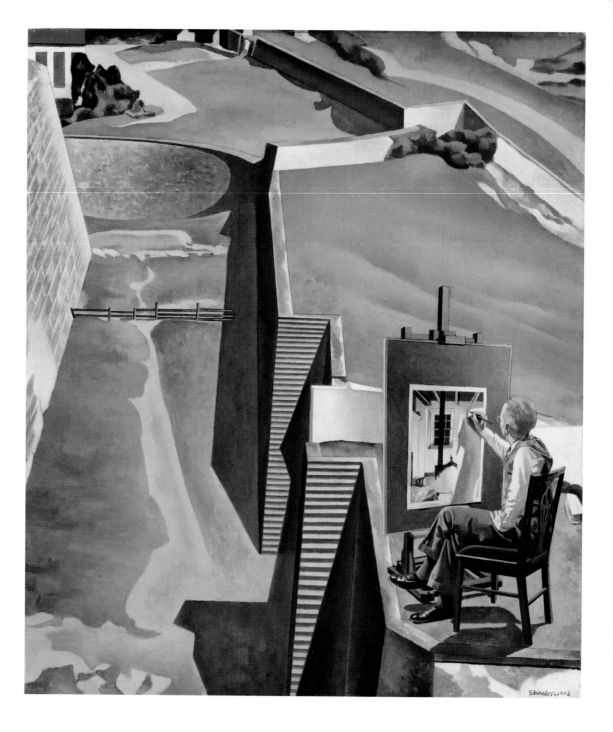

A

Charles Sheeler, *The Artist Looks at Nature*, 1943. Oil painting.

Where do you see organic shapes? Where do you see geometric shapes?

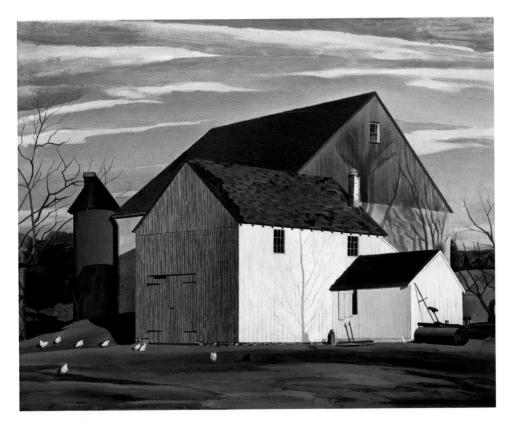

Charles Sheeler, *Bucks County Barn*, 1932. Oil painting.

What do you think the artist wants you to notice first? Why?

We all care about the places where we live. For thousands and thousands of years, people have built homes and planned communities as a way to improve their lives.

We are constantly changing the look of the spaces and places around us. Artists often help people plan for the changes they want to make. Some artists design buildings and plan neighborhoods.

Artists also use the human-made environment as subject matter for their artworks. They look closely at the structures and details of architecture and record what they see.

Meet Charles Sheeler

Charles Sheeler lived in a farmhouse in rural Pennsylvannia. He was a photographer as well as a painter. Many of his paintings were based on his photographs. He carefully copied every detail in the views he chose to paint. Because his paintings were so carefully made and precise, people called him a "precisionist."

Picturing Open Spaces

Vocabulary

English Spanish
unity *unidad*

You can see beauty in open spaces. When farmers plant fields like those you see in , they follow the curves of the hills and plant strips of crops, like corn, next to strips of grass or hay to control erosion. The result is a beautiful view.

Artists can show us the beauty of our land. The curved lines in **B** and **C** suggest energy and paths of movement. The lines help to lead your eyes through rows of dark and light spaces.

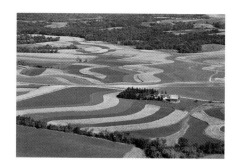

A

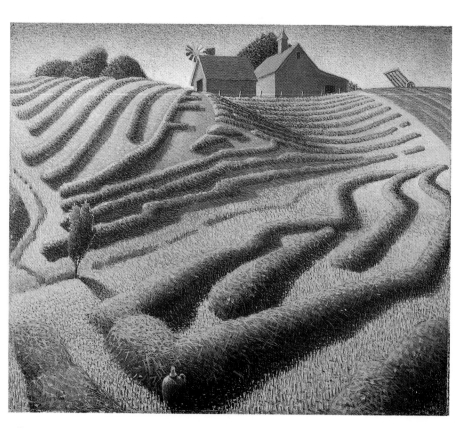

B Grant Wood, *Haying*, 1939. Oil painting.

Art © Estate of Grant Wood/Licensed by VAGA, New York, NY.

C Marsden Hartley, *New Mexico Landscape*, 1919. Oil Painting

Lines in landscape give unity to the variety of colors and shapes. Unity means that lines, shapes, and colors are working together, like a team.

Line in Landscape

Use markers to draw a view of the land.

- Think about open spaces you have seen. Think about the lines and shapes that go with open spaces. The lines and shapes may be straight, choppy, zigzagging, or graceful.
- Draw your lines on paper to give unity to the design.
- Add colors and other details to your work.
- Create an artwork filled with many repeated lines.

D Student artworks

Textures in Places

Vocabulary

English	Spanish
real texture	*textura real*
visual texture	*textura visual*

When you hold a rock or a stick, you are touching a surface that has texture. Textures can feel rough, smooth, gritty, or fluffy. Textures that you can feel by touch are called real textures.

You also can identify textures just by seeing them. Visual textures are small patterns of repeated marks, as in the open field you see in 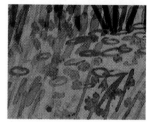 and up close in B.

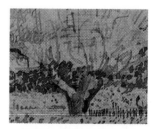

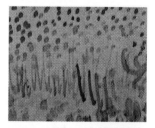

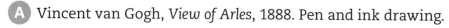

A Vincent van Gogh, *View of Arles*, 1888. Pen and ink drawing.

B Vincent van Gogh, *View of Arles* (three details).

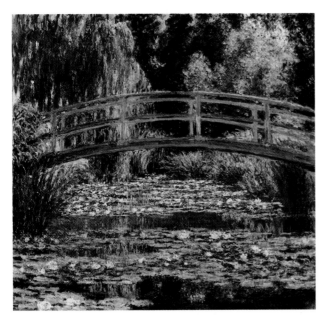

C Claude Monet, *Japanese Footbridge and the Water Lily Pond, Giverny*, 1899. Oil painting.

Artists also suggest textures by showing light and shadows and by changing colors, as in C.

About the Artist

Impressionist painter Claude Monet created a magnificent garden at his home in Giverny, France. He spent his last years painting scenes from his garden. He captured the way things looked at different times of day and in different seasons.

Showing Texture

You can make a painting that shows both real and visual textures.

- Try different ways to show texture with paint.

- Explore patterns of repeated brushstrokes or visual texture.

- Practice combining tints and shades for small areas of color to show light and shadow.

- Use black paper for your painting.

- Outline the main shapes with thick glue lines. Allow the glue to dry overnight. This will add to the real texture of your painting.

- Apply paint to areas inside the raised glue lines to create visual textures.

D Student artwork

Unity, Variety, and Texture
A Place for Quiet Times

Materials you will need
- sturdy cardboard box lid
- natural materials:
 stones, pebbles, twigs,
 acorns, bark, moss, etc.
- small plastic bags
- sand
- plastic forks

Read, Look, and Learn

In Japan, many people plan beautiful gardens. The gardens are places where you can see and think about natural beauty. Japanese gardens have large rocks and bushes arranged in irregular groups. The ground is covered with small pebbles raked into patterns that suggest ocean waves, running water, or clouds. Because Japanese gardens are planned to be informal and irregular, they have asymmetrical balance.

In many parts of the world, a person who designs outdoor spaces is called a landscape architect.

Think about a vacant lot in your community. You can make a model of the lot or a plan for changing it into a place for quiet times. You can use rocks, sand, and twigs.

Remember to:

✔ Use a variety of natural materials and real textures.

✔ Create unity by repeating lines and other elements.

✔ Make your plan an asymmetrical design.

Step 1: Plan and Practice

- For ideas, look at the pictures of Japanese gardens shown on these pages.

- Collect materials that you think you might use.

- Look for such things as stones, small pieces of wood, twigs, pebbles, acorns, and moss.

- Study them for their textures and forms.

Inspiration from Our World

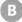 B

Vocabulary

English	Spanish
asymmetrical balance	*equilibrio asimétrico*
landscape architect	*arquitecto de paisajes*

Inspiration from Art

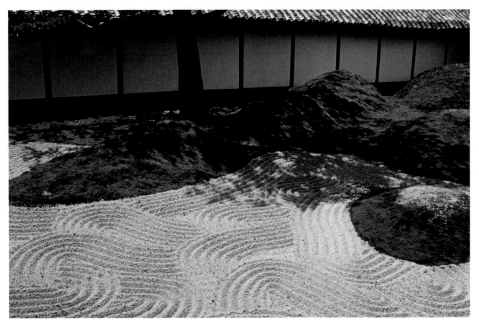

A

Mirei Shigemori,
Tofuku-ji Hondo,
1939.

Japanese gardens are like nature in miniature. Arrangements of rocks can be seen as mountains or islands. The raked pebbles can be seen as ocean waves. What does the moss growing on the rocks remind you of? How is this a peaceful place?

C

D

Step 2: Begin to Create ⟶

- Prepare your box lid.
- Should you cover the outside with paper or paint?
- Experiment by combining your natural materials in different ways to suggest such things as paths, islands, mountains, benches, and gates.

Cover the bottom of your box lid with sand. Distribute evenly.

Step 3: Revise

- Have you used a variety of materials and real textures?
- Did you unify your garden design with lines and other elements?
- Have you created an asymmetrical design?

Step 4: Add Finishing Touches

- Imagine that a person could enter into your small garden space.
- Does it need a path?
- Have you provided a place for sitting and reflecting on the beauty of nature?
- Do you need to add any other elements to your garden plan?

Sketchbook Connection

Sketch a tree or shrub. Imagine how you could shrink it. Look carefully at your drawing. What can you shorten? How will you maintain the overall shape of the tree or shrub?

Step 5: Share and Reflect

- Display your model along with those made by your classmates.
- Write a haiku to describe your quiet place.
- Tell your classmates about your reasons for choosing the materials you have placed in your garden space.
- Explain what they represent.

Quick Tip

Walk around your yard or garden and find interesting shrubs. Ask permission to clip a small piece of a branch from a shrub you like. You can use it in your model garden. Secure it with a small piece of clay.

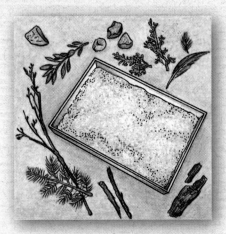

Choose materials for your garden.

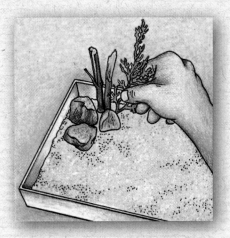

Arrange objects asymmetrically. Repeat objects for unity.

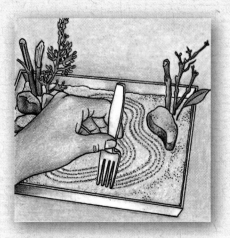

Create lines in the sand to symbolize flowing water or ocean waves.

Art Criticism

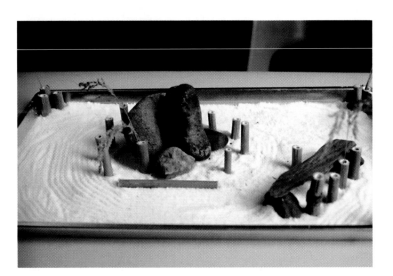

A Student artwork

Describe
What materials did the artist select for the garden model?

Analyze
How is the arrangement asymmetrical?

Interpret
What ideas about nature does the garden model suggest?

Evaluate
Would this be a successful model for a real garden? Explain your answer.

Creating a Model

Architects are artists who design buildings. They plan the forms you see in a building. The forms are designed to be walls, roofs, and other parts of the building.

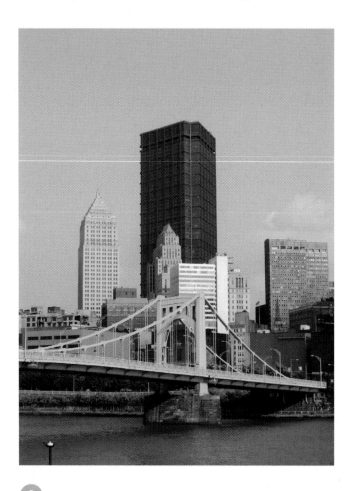

A

Look for forms like these in buildings. These forms have curved edges.

B sphere cone cylinder

These forms have straight edges.

C cube pyramid slab

Many architects combine forms like cones, cylinders, and cubes in one building. Sometimes a whole building has one main form, such as a pyramid. Picture A shows many buildings with different forms. Are there forms like these in the buildings in your town?

Dream Building

Make a model for your dream clubhouse.

- Collect small boxes, paper cups, and other forms.

- Try combining forms in different ways. You can construct your model from square or rectangular pieces of cardboard. You also can make forms from folded paper as in 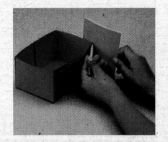.

- Use glue and tape to join the parts of your model.

- Can you add details?

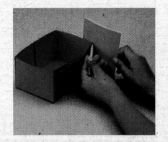
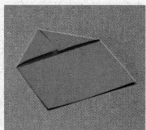
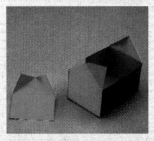
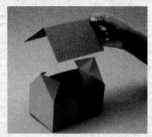
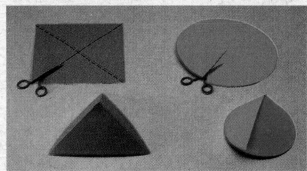

D

E Student artwork

On the Outside

Have you ever noticed textures and patterns on the exteriors of buildings? Bricks, concrete, and wood have texture. They can be put together in many patterns.

The building in Ⓐ has fancy brickwork combined with rows of stone. The pattern looks like a relief sculpture. Parts of the design are raised up from a flat background.

Vocabulary

English	Spanish
pattern	*patrón*
exterior	*exterior*
materials	*materiales*

Today's architects often use smooth materials such as concrete, glass, and steel. Notice the patterns created by repeated rectangles in Ⓑ. Many buildings have textures and patterns made from different materials. The 600-year-old wooden church in Ⓒ is in Russia. How would you describe the pattern?

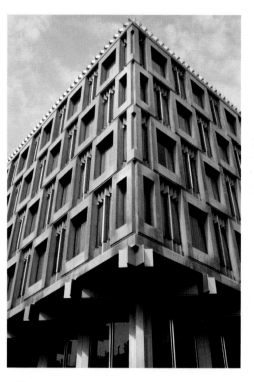

Ⓐ John Frances Bentley, *Westminster Roman Catholic Cathedral*, 1895–1903.

Ⓑ Eero Saarinen, *United States Embassy*, Gernode, Germany, 1960.

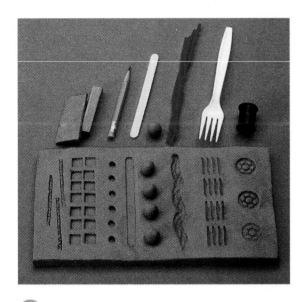

C Lazarevskaya Church, 1350–1399.

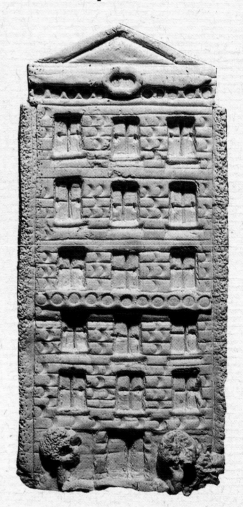

D

Outside Relief

You can make a relief sculpture of the exterior of a building.

- Make a flat slab of clay about as thick as your thumb.
- Practice making patterns and textures, such as the ones you see in D, by pressing objects into clay.
- After you experiment, make your relief sculpture.

E Student artwork

Interior Design
Trading Spaces

Materials you will need
- large square of colored paper
- magazines and patterned papers
- craft sticks
- colored pencils and markers
- scraps of fabric
- assorted found objects
- scissors
- glue

Read, Look, and Learn

Interior designers are artists who plan colors, patterns, and textures of spaces inside a building. They often choose furniture and plan its arrangement.

Designers often work with customers. They create a floor plan that shows the room's dimensions and the location of windows and doors.

Interior designers consider the purposes of a space and the feeling or mood desired by the people who live, work, or play there. For example, a playroom might have lively shapes and bright colors.

You can imagine that you are an interior designer. Design a new room for a classmate who is your customer.

Remember to:

✔ Plan a room for a particular purpose.

✔ Include your customer's wishes for colors and textures.

✔ Make a model of the room with walls, floor, and furniture.

Step 1: Plan and Practice

- Interview your customer to learn about the purposes of the room.

- Find out what colors your customer likes. What special features would he or she like to have in the room?

- Make a floor plan. Decide where the windows and doors will be. Plan for the arrangement of furniture.

- How can you suggest rugs, chair coverings, and other details?

Inspiration from Our World

Vocabulary

English	Spanish
interior designer	*diseñador de interiores*
floor plan	*plano de planta*

Inspiration from Art

Frank Lloyd Wright, Arthur Davenport House, 1901.

The windows, walls, floors, and furniture in this house were all part of the planned interior design. For what purpose do you think this room was designed? What do you see in the room that helps you think this?

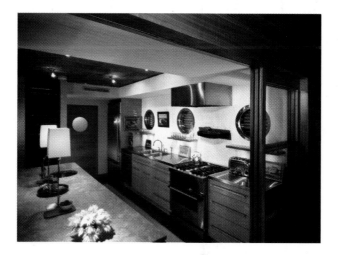

C

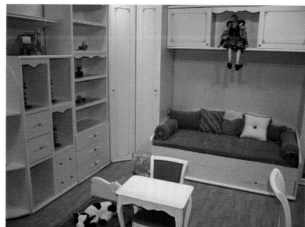

D

Step 2: Begin to Create

- Make a model of the room you have planned.
- Your model will be 8" x 10" and will have 5" walls.

Step 3: Revise

- Is the purpose of the room clear?
- What could you do to make sure that people who see the model can tell what its purpose is?
- Have you paid attention to your customer's wishes for colors and textures?

Step 4: Add Finishing Touches

- What final details can you add to the parts of the room? Did you remember to show doorknobs, window coverings, and lighting fixtures?

Step 5: Share and Reflect

- Present your completed room model to your classmate customer.
- Discuss how you believe the room you designed shows your customer's wishes.
- Ask your customer to tell you what she or he especially likes about the room you have planned.

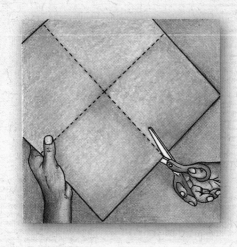

Fold a square paper in half twice. Unfold and cut along one crease to the middle.

Quick Tip

Visit the paint department at your local hardware store. You are welcome to take some paint chips (paint colors printed on small-sized papers). Find the colors your classmate customer would like. You can match the paint chips to the other materials you want to use.

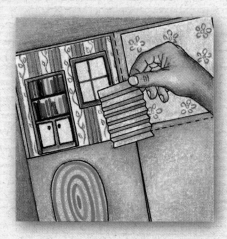

Use paper scraps, magazine cut-outs, and markers to design your room.

Fold paper to create furniture for your room.

Construct your room with tape and add furniture.

Art Criticism

A Student artwork

Describe
What kind of room did the interior designer create for the customer? What parts of the room provide clues to its purpose?

Analyze
What colors are important in the room model? How did the designer make the parts of the room go together?

Interpret
What mood or feeling might a person have when entering this room?

Evaluate
What do you like best about this room model? What did the interior designer do especially well?

Symbols on Walls and Floors

Mosaics are pictures or designs made up of tesserae, small pieces of colored glass, marble, or other materials. Mosaics, like the one shown in **A**, are often used to decorate the interior walls or floors of churches and other buildings

Artists can arrange mosaic designs using symmetrical, asymmetrical, or radial balance.

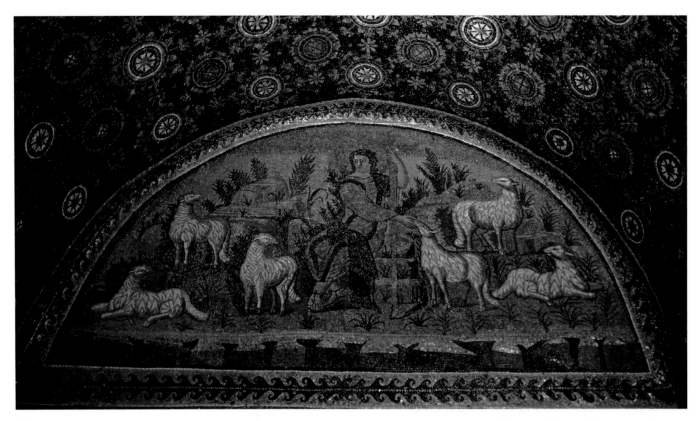

A *Mausoleum of Galla Placidia, interior: Good Shepherd mosaic, 425–450 CE.*

Vocabulary

English	Spanish
mosaic	*mosaico*
tesserae	*tesserae*
symmetrical balance	*equilibrio simétrico*
radial balance	*equilibrio radial*

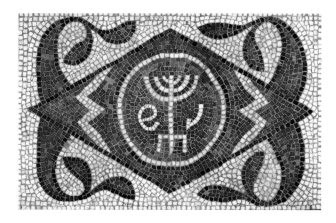

B Unknown, *Mosaic of a Menorah with Lulav and Ethroq*, 500s CE.

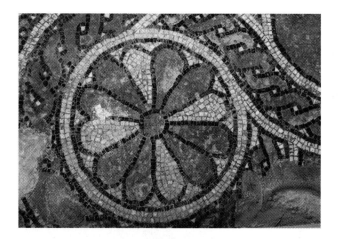

C *Chapel detail: mosaic floor, 400s CE.*

Symmetrical balance means that both sides of the design are exactly or nearly the same. Where do you see symmetrical balance in B?

The mosaic in C shows **radial balance** because the petal shapes spread out from a center point.

Create a Mosaic

You can create a mosaic with paper. Plan your design to show symmetrical or radial balance.

- Decide on a group of colors you will use.
- Make sketches that show the main shapes and outlines of your design.
- Cut or tear tesserae from colored paper.
- Glue them down neatly side by side.

D Student artwork

Buildings That Matter

Vocabulary

English	Spanish
memorial	*monument conmemorativo*

Around the world, people create buildings for special reasons. The buildings you see here were constructed long ago in different countries. Each one has a special purpose.

The Taj Mahal in **A** is in India. It honors the memory of a woman. It is a memorial building.

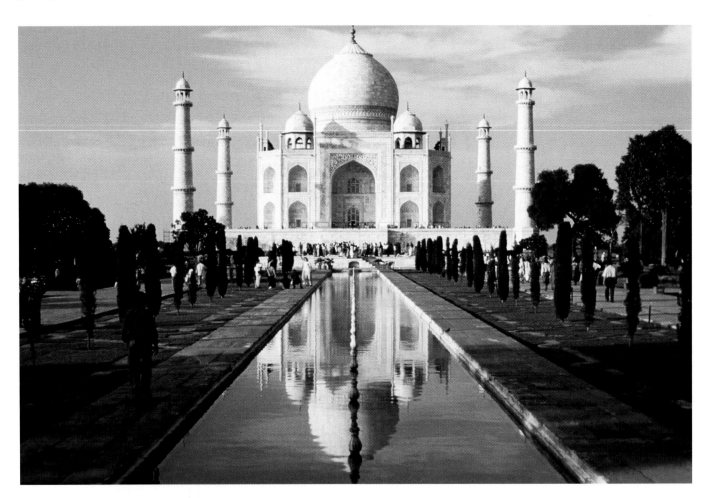

A Ustad Amad Ma'mar Lahori, The Taj Mahal at Agra, 1632.

The building in **B** is in Japan. It was constructed about 600 years ago. It was built as a study space for a military ruler.

The church in **C** is in Russia. The building has many fancy patterns of brick and stone. Some of the surfaces are painted with many colors.

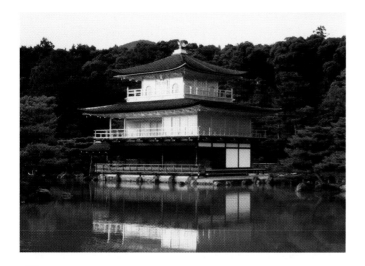

B Rokuon-ji, Golden Pavilion, 1934–1427.

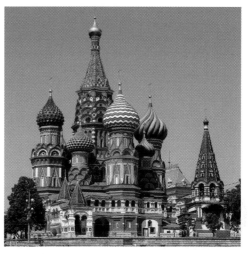

C Postnik Yakoviev, St. Basil's Cathedral, 1555–1561.

A Local Treasure

Most communities have buildings that are very special. Think about a building in your community that is a special treasure to you. It should be a building you would like everyone to admire and take care of for a long time. What is its purpose?

- Draw a picture of this special building with your choice of drawing materials.
- Try to remember everything you can about the building.

- Is it tall or wide? How does its roof look? What patterns of brick or stone does it have?

D Student artwork

Landmarks
Our Colorful Town

Materials you will need
- choice of drawing media
- choice of paper sizes and shapes

Read, Look, and Learn

A landmark is a place in a neighborhood or town that almost every person knows about. Historical landmarks are old buildings or places that help people remember the past. The painting in 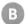 shows a famous bridge. The artist painted with bright and bold colors that he liked. Some people called his paintings "wild."

Choose a landmark to draw using bright and bold colors of your choice. It does not have to be a famous building. It can be any place or building you know that people want to see or visit.

Remember to:

✔ Show the main part.

✔ Create a place with simple lines and shapes.

✔ Select colors that appeal to you.

Step 1: Plan and Practice

- Brainstorm with your classmates to remember landmarks.
- Choose one to feature in your drawing.
- What are the main parts of this landmark?
- How can you show it with simple lines and shapes?
- Make some sketches before you decide on an arrangement of shapes.

Inspiration from Our World

B

Vocabulary

English	Spanish
landmark	*monumento histórico*

Inspiration from Art

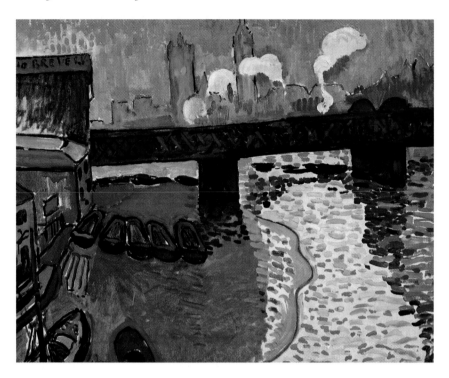

André Derain, *Charing Cross Bridge*, 1906. Oil painting.

André Derain painted famous bridges and other landmarks in London, England. He used very simple lines and shapes to exaggerate the landmarks' forms. Where do you see simple shapes and bold colors in this painting?

C

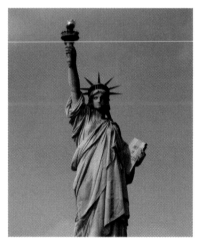

D

Step 2: Begin to Create →

- With a pencil or crayon, draw large shapes to show the main parts of your chosen landmark.

- How much of your paper will you fill with the landmark?

Draw a local landmark from memory with pencil or crayon.

Step 3: Revise

- Have you included the main parts of your chosen landmark?

- Have you exaggerated its form with simple lines and shapes?

- Have you selected a combination of colors that you like?

Step 4: Add Finishing Touches

- Have you included buildings, a street, or other things that surround your landmark?

- You can add lines to show details of the landmark and its surroundings.

- Should you add any more color?

Step 5: Share and Reflect

- Display your artwork with those of your classmates.

- Have you and other classmates shown the same landmark? If so, how are they similar? How are the artworks different?

- Are you pleased with your drawing?

- Would you want to draw the same landmark again or a different landmark?

Sketchbook Connection
Take a walk in your town or city neighborhood. Jot down all the landmarks you find. Make a quick sketch of each one.

Include the unique features of the landmark.

Add new features to the landmark, such as texture, color, and pattern.

Use crayons or markers to complete your drawing.

Art Criticism

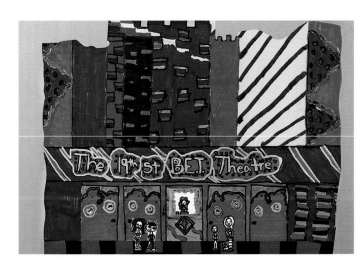

A Student artwork

Describe
What landmark did the artist show? What are your clues?

Analyze
Where do you see simple shapes and lines? What color combination did the artist include?

Interpret
In what ways did the artist make her landmark "wild"?

Evaluate
What did the artist include that makes this artwork especially good?

Presenting Places
Living Together

In the Past

About 800 years ago, the Native American Anasazi people constructed stone and wooden dwellings in caves protected by cliffs. Mesa Verde, in southwestern Colorado, contains some of the best-preserved cliff dwellings in the Southwest. Cliff Palace is the largest cliff dwelling in North America. It has over 200 rooms and probably had a population of 200 to 250 people.

Anasazi,
Cliff Palace,
1100s–1200s.

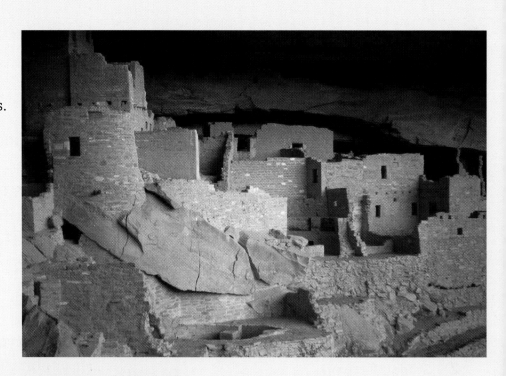

In the Past

1100s–1200s

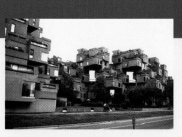

1964–1966

In Another Place

About 40 years ago, the Israeli architect Moshe Safdie had an idea for city housing. He designed a way to put many houses in a place with little land. He combined over 300 pre-cast concrete units to create this structure, called Habitat, in Quebec, **Canada**. He used huge cranes to lift and stack the concrete forms like gigantic building blocks.

Canada

Atlantic Ocean

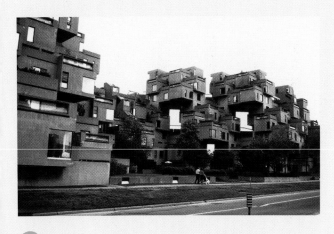

B Moshe Safdie, *Habitat*, Montreal, 1964–1966.

In Daily Life

Some people, when they travel, take their homes with them. Many state and national parks have special places for campers and mobile homes. Sometimes mobile homes become permanent dwellings.

In the Present

C

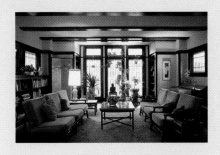

a

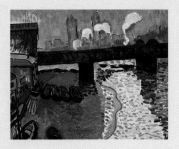

b

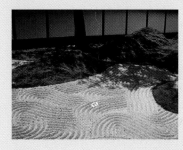

c

d

Match each sentence to a picture.

1 an example of landscape architecture
2 texture and pattern on a building exterior
3 an example of interior design
4 a painting with bold colors and simple shapes

Write About Art

Imagine you are sitting before the open window in the painting in Ⓐ and writing a postcard to a friend. Describe what you are seeing inside the room as you look around you. Then describe the view out the window. You might begin your message: "I wish you were here because . . ."

Aesthetic Thinking

Real estate agents often take pictures of the houses they are trying to sell. They use the photographs in newspaper and magazine advertisements. Are all photographs that people take of buildings, bridges, and other places considered artworks? Why or why not?

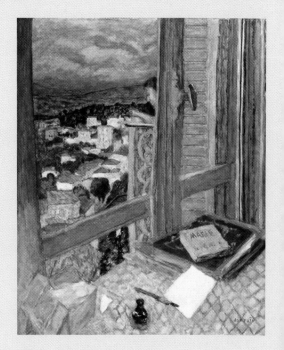

Ⓐ Pierre Bonnard, *The Window*, 1925. Oil painting.

Art Criticism

B Berenice Abbott,
*Walkway, Manhattan
Bridge*, 1935.
Gelatin silver print
photograph.

Describe

What do you see in this photograph? What words can you use to describe the lines and shapes?

Analyze

Where do your eyes seem to go when you first look at this photograph? Why? How did the photographer create the illusion of deep space and distance in this photograph?

Interpret

How do you get a sense of the great strength and towering size of a bridge when you view this photograph?

Evaluate

If you had the opportunity, would you like to see more photographs taken by this photographer? Why?

Meet Berenice Abbott

American photographer Berenice Abbott was born in Springfield, Ohio. She spent several years taking pictures of New York City. She photographed the city during different times of the day and night. Sometimes she photographed the city from the air. At other times, she focused on details of buildings and bridges.

Art History and Culture

Before the 1930s, many people did not consider creative photographs to be art. That changed when museums and galleries in the United States began to exhibit photographs.

Nature's Gifts
Making Choices

Ⓐ Rosa Bonheur, *Wild Boars in the Snow*, 1872–1877. Oil painting.

What do you notice first? Why?

We all benefit from the many things that nature provides.
Most of what we need to live comes from nature. Because we see nature as the provider of our basic needs, we sometimes forget to enjoy the beauty of nature.

Artists help us to see the beauty of the natural world. They create artworks showing the beauty of wildlife and pets. They paint landscapes that remind us that nature can be calm and peaceful. They use materials found in nature to create beautiful objects, reminding us yet again of nature's many gifts.

B Rosa Bonheur, *Recumbent Stag,* ca. 1850–1890. Watercolor painting.

Does this animal seem real to you? Why or why not?

Meet Rosa Bonheur

Rosa Bonheur learned to paint from her father, who was a landscape painter. She liked animals and made them the subjects of most of her paintings. To learn more about how the bones and muscles of animals worked, she visited the local butcher shop and made detailed sketches. These studies helped her to understand the structure and form of the animals she painted.

In the Wild

Vocabulary

English Spanish
emphasis *énfasis*

Artists who want to share a strong feeling about animals often give importance, or emphasis, to one feature of an animal more than to others. In Ⓐ, you see the very rough texture of the alligators' skin.

The artist also has emphasized the curved shapes of the alligators resting in the sun. Why do you think the artist chose to emphasize these features? What ideas and feelings about alligators does the artwork give you?

Ⓐ John Singer Sargent, *Muddy Alligators*, 1917. Watercolor painting.

Melissa Miller, *Flood*, 1983. Oil painting.

In B, the artist emphasizes curves and strong contrast between horizontal and vertical forms to show the movements of animals trying to escape a raging flood. What does this painting make you think about?

Studio Time

Feelings About Animals

You can create an expressive drawing of a real or imaginary animal with oil pastels.

- Think of a real or imaginary animal and your feelings about it.
- Make sketches to try out ideas for the view and the size of the animal.
- Explore ideas for colors and textures.
- Choose your best sketch.
- Plan your drawing to include areas of emphasis.

C Student artwork

Animals at Play

Picture Ⓐ is a print. To make the print, American artist Wanda Gag carved a picture in a smooth block of wood. She put thick ink on the wood and pressed the paper against the ink. She made many prints in this way. What is the main center of interest in this print? How did the artist lead your eyes toward this area?

Vocabulary

English	Spanish
print	*grabado*
center of interest	*punto de interés*
brayer	*rodillo de goma para entintar*

Japanese artist Okyo Maruyama painted the three puppies in Ⓑ. Most people probably see the dark puppy first. That puppy is the center of interest. A center of interest is the first thing you notice when you look at an artwork.

Ⓐ Wanda Gag, *Cats at the Window*, 1929. Wood block print.

Okyo Maruyama,
Three Puppies, 1790.
Ink drawing.

Studio Time

Relief Printing

You can make a print showing an
animal at play.

- Draw lines, shapes, and textures
 into a block of Styrofoam.

- Plan the drawing for your animal
 print on thin paper. If you turn the
 paper over, you can see the reversed
 image. Trace this reversed image on
 your piece of Styrofoam.

- Use a pencil or pointed stick
 to draw, or "carve," the lines into
 your block.

- After you prepare the block,
 put ink or paint on it. A brayer
 is a roller artists use to apply ink.

- Put your paper on top of the inked
 block. Rub the back of the paper
 gently. Lift the paper carefully.

 Student artwork

Collagraph
Creatures Up Close

Materials you will need
- drawing paper
- pencil
- white glue and glue stick
- posterboard
- cardboard
- paintbrush
- printing ink
- brayer
- construction paper

Read, Look, and Learn

If you look closely at things in nature, you see that they have main shapes and smaller shapes. When you draw trees, flowers, birds, fish, and other creatures, first look for their main shapes. Look for smaller shapes inside or around the main shapes. Draw these next.

You can turn your drawing into a collagraph. A collagraph is a print made from a surface that has been made like a collage. Cardboard shapes and other materials are glued to a heavy piece of cardboard to make a printing plate. More than one collagraph can be made from this one printing plate.

Remember to:

✔ Plan for a center of interest in your close-up drawing of a creature.

✔ Show main shapes and smaller shapes.

✔ Fill your printing plate from edge to edge.

Step 1: Plan and Practice

- Choose a creature to draw.

- To get ideas, look at the pictures on these pages and through books and photographs of creatures found in nature.

- Practice by making some sketches. Look for main shapes and smaller shapes.

Inspiration from Our World

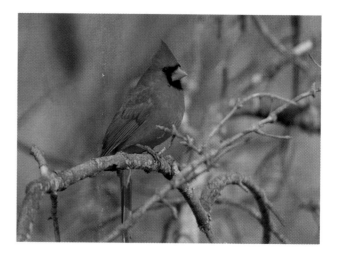

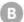 **B**

Vocabulary

English	Spanish
collagraph	colográfico

Inspiration from Art

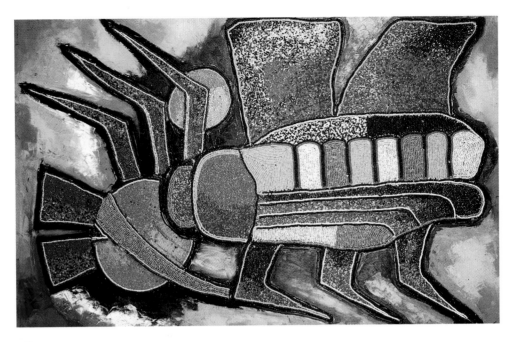

A Jimoh Buraimoh, *Insect*, 1973. Beads and wood.

What shapes do you see repeated in this beaded artwork?
Can you see different insect body parts? Where do you see main shapes? Where do you see smaller shapes?

C

D

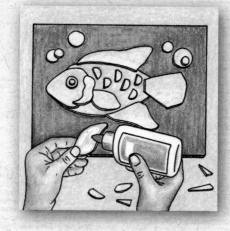

Step 2: Begin to Create

• Draw a close-up picture of a creature on a cardboard base.

• Use your drawing as a guide for creating a printing plate from posterboard shapes.

Step 3: Revise

• Have you cut out main shapes to show your creature up close? Have you added smaller shapes?

• Did you create a center of interest?

• Have you filled the printing plate from edge to edge?

Cut out main and smaller shapes from posterboard and glue into place on heavier cardboard. Allow to dry.

Step 4: Add Finishing Touches

• Make several prints. Re-ink your plate each time.

• Remember to sign, number, title, and date your prints.

Step 5: Share and Reflect

• Prints usually look better when they are mounted for display.

• Choose your best print to display along with those made by your classmates.

• How does this printing process compare with other ways you have learned to make prints?

Sketchbook Connection
Use your sketchbook to plan which parts of your creature you will cut out.

Portfolio Tip
Choose the print you like best to include in your portfolio. What do you like about it?

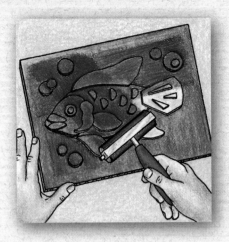 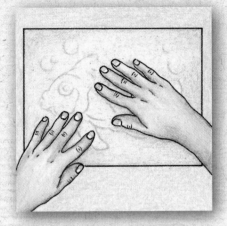 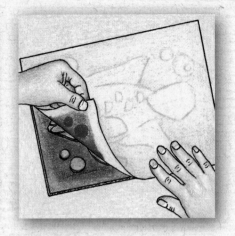

Use a brayer to roll ink from side to side and top to bottom.

Place a sheet of paper over the inked plate and rub gently and evenly with your fingers.

Carefully lift the paper from the printing plate.

Art Criticism

A Student artwork

Describe
What creature did the artist show?

Analyze
How did the artist plan for a center of interest?

Interpret
If this print were going to be used on a greeting card, what kind of message would be on the inside of the card?

Evaluate
Do you think the colors of the ink and paper were good choices for this subject matter? Why or why not?

The Light of Day

Artists plan the colors in their artworks. A plan for choosing colors is a color scheme. The color wheel in Ⓐ can help you understand some ways to plan a color scheme.

André Derain used complementary color schemes in the painting in Ⓑ. Complementary colors are opposite each other on the color wheel.

Vocabulary

English	Spanish
color scheme	*combinación de colores*
complementary colors	*colores complementarios*
analogous colors	*colores análogos*

They create strong contrasts that get your attention. What are the complementary colors in Derain's painting?

André Derain often worked outdoors. He had to paint a scene quickly before the light and color changed. To do this he used short, rapid brushstrokes.

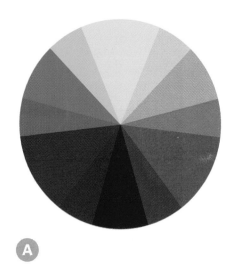

Ⓐ

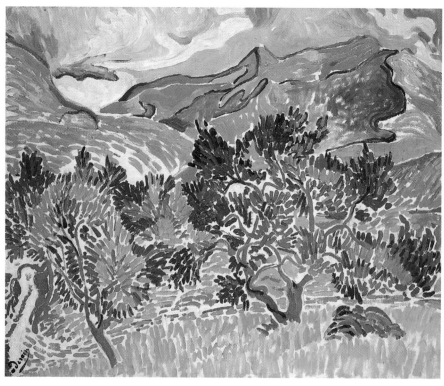

Ⓑ André Derain, *Mountains at Collioure*, 1905. Oil painting.

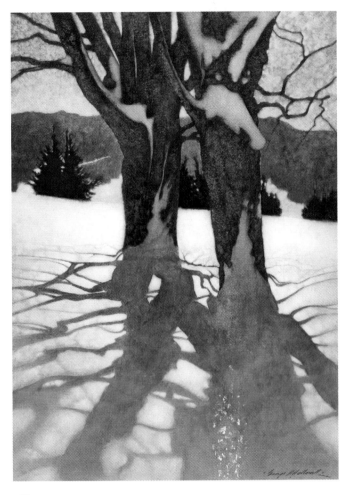

The painting in **C** is planned around a related, or analogous, color scheme. Analogous colors are next to each other on the color wheel. What are the analogous colors in **C**?

C George Hawley Hallowell, *Trees in Winter*, ca. 1910. Watercolor painting.

Studio Time

Time of Day

Sketch some ideas for a painting to show nature at a special time of day.

- Plan the scene using analogous or complementary colors.
- What kind of light will you show?
- What brushstrokes will you use?

D Student artwork

Looking at the Land

A landscape is an artwork with an outdoor scene as the main subject. Both of the paintings in this lesson are landscapes. What kind of scene does each painting show?

The painting in Ⓐ glows with tints of warm colors. The artist chose these colors to show sunlight on the rugged cliffs.

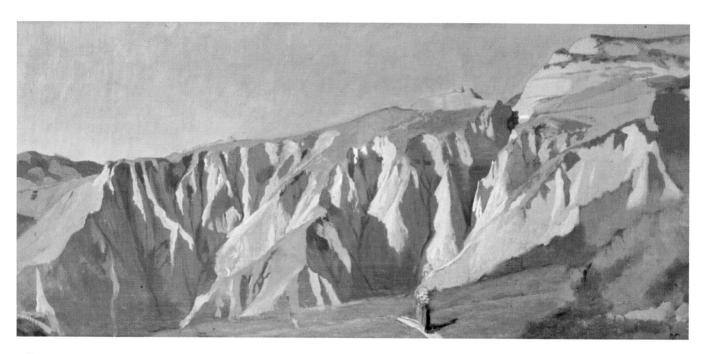

Ⓐ Elihu Vedder, *Cliffs of Volterra*, 1860. Oil painting.

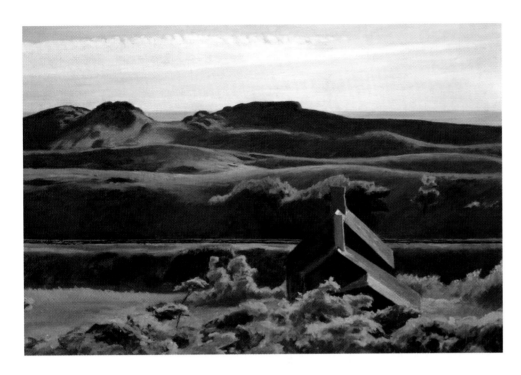

B

Edward Hopper,
Hills, South Truro,
1930. Oil painting.

The painting in **B** has tints and shades of cool colors. These colors show the evening light on rolling hills. Why do you think the artist used cool colors for this scene?

Artists plan their artworks with warm and cool colors to show different places and things. Warm and cool colors can also give you different moods or feelings.

Studio Time

Landscape Drawing

You can make an oil pastel drawing of a landscape.

- Think about places you have seen in pictures or in real life.

- Choose warm or cool colors for your artwork.

- Create a definite mood or feeling by using many kinds of warm colors or many kinds of cool colors.

C Student artwork

Materials you will need
- paper
- crayons
- watercolor paints
- brushes

Unity and Variety
Natural Habitats

Studio Introduction

Some artists like to show how living things depend on each other in the natural environment. They notice the special kinds of plants and creatures that live in one place.

Picture **A** is a painting of plants and birds that we might find near a lake or an ocean. The artist planned the painting carefully. He repeated certain colors to add unity to the painting and to lead our eyes around the picture.

Create a crayon resist painting that shows a variety of living forms in a natural habitat. You might show a jungle, a desert, canyon life, or an underwater scene.

Remember to:

✔ Choose one main creature as a center of interest and show a variety of other creatures.

✔ Show the environment in which the creature lives.

✔ Select a color scheme and repeat certain shapes to unify the picture.

Step 1: Plan and Practice

- Look at the photographs of habitats on these pages.

- Find out as much as you can about your choice of a natural environment.

- Make some sketches that show the many living things one would find in that environment.

- Make notes about colors, textures, and details.

Inspiration from Our World

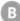 **B**

Vocabulary

English	Spanish
resist painting	*cuadro de resistencia*

Inspiration from Art

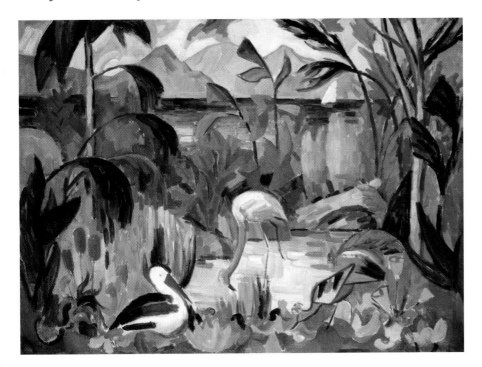

Jean Metzinger, *Colorful Landscape with Aquatic Birds*, ca. early 1900s.

Where do you see repeated shapes and colors? What color schemes can you find? How has the artist planned for your eye to move around the painting?

C

D

Step 2: Begin to Create ➝

- Will your painting be horizontal or vertical?
- Start with light, sketchy lines.

Step 3: Revise

- Have you shown a main creature for a center of interest?
- Did you include plants and other creatures that are important to each other?
- Have you unified the picture with repeated shapes and a color scheme?

Draw a natural environment on white paper in light crayon.

Step 4: Add Finishing Touches

- When you are pleased with your crayon drawing, brush watercolor paint over your picture.
- The paint will roll off of the waxed surfaces left by the crayons.

Step 5: Share and Reflect

- Find a classmate who created a picture about a similar natural environment. Discuss your completed pictures.
- How did you each create a center of interest?
- What color schemes did you plan for your natural environment?

Quick Tip
Be sure to color firmly when finishing your drawing.

Add details to your scene.

Unify your picture with repeated shapes and a color scheme.

Brush over your scene with watercolor paint.

Art Criticism

A Student artwork

Describe
What kind of natural environment did the artist show in this artwork?

Analyze
Where do you see repeated colors and shapes?

Interpret
What creatures depend upon each other?

Evaluate
Was the artist successful in creating unity in this artwork? Explain your answer.

Tools from Nature

Have you ever used a stick to make lines in the dirt or sand? It is fun to see the different kinds of lines you can make. What kind of line does a skinny stick make? How is it different from the line made with a wide stick? What happens if you push lightly on the stick? What happens if you use more pressure?

Artists like to ask these kinds of questions when they explore line qualities. Line quality is the way a line looks. The artists who made the artworks in Ⓐ and Ⓑ paid attention to line qualities. What tools do you think they used? How much pressure did they use?

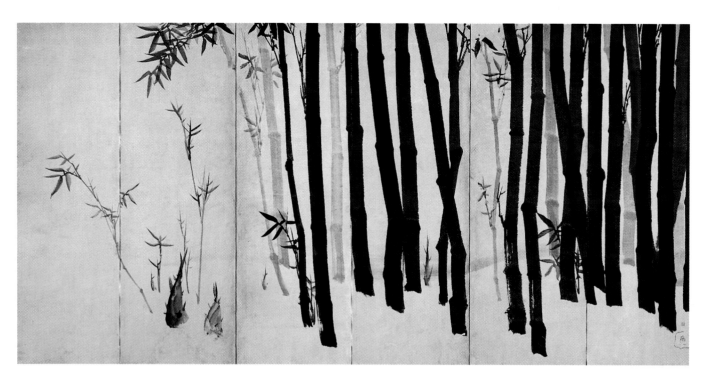

Ⓐ Nagasawa Rosetsu, *Bamboo*, 1700s. Ink on paper mounted on wooden frame.

B

Vincent van Gogh,
Haystacks, 1888.
Pen and ink drawing.

Studio Time

Natural Marks

Make different kinds of lines.

- Draw with sticks dipped into paint or ink.

- Try using thick sticks. See how these lines are different from those made with thin sticks.

- Push lightly on the stick. Push a little harder. See the differences.

- Fill a large paper with different kinds of lines.

- Share your collection with a classmate and talk about how they are similar and different.

C Student artwork

Gifts from Nature

Vocabulary

English	Spanish
vessel	*recipiente*
paper pulp	*pasta de papel*

Many artists gather materials from nature to make their art. Carrie Nordlund collects souvenirs from nature. She combines seeds and twigs with handmade paper to create vessels, or containers, like the one you see in Ⓐ and Ⓑ. She made a round form with recycled paper and walnut-tree sticks. She glued hundreds of seeds to the outside of the vessel.

Ⓑ Carrie Nordlund, detail, closeup of *Untitled, Seed Series*.

Ⓐ Carrie Nordlund, *Untitled, Seed Series*.

Artists in Kenya, a country in Africa, use recycled paper, natural fibers, and other natural materials to create simple, cylindrical vessels. The container in **C** is decorated with a braided rope of fibers.

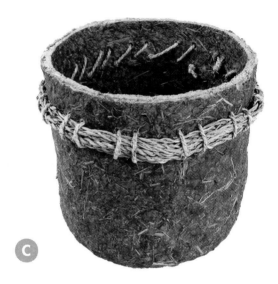

C

Did you know that paper is one of nature's gifts? Every time you use a piece of paper, you are using a material that nature provided.

Recycled Vessels

Make a bowl from recycled paper.

- Soak bits of paper in water overnight.
- Mix soaked paper with water in a blender to make paper pulp.
- Strain water from the pulp.
- Mix pulp with glue or liquid starch to make it smooth.
- Press the pulp and natural materials into a mold.
- Use a sponge to soak up excess water. Dry for several days.
- Remove from the mold and decorate the outside.

D Student artwork

Coil Method
Containers from the Earth

Read, Look, and Learn

Clay is one of nature's most precious gifts. For thousands and thousands of years, people have used soft, moist earth or clay to make pottery. One of the earliest ways for making pots was to join coils, or rope-like pieces of clay. Artists in cultures around the world continue to use the coil method when they make pots, bowls, and even large sculptural figures.

Karita Coffey used clay to make the sculpture in Ⓐ. The clay sculpture was baked in a special oven called a kiln. This step is known as firing the clay because the kiln gets as hot as a fire.

You can create clay pottery using the coil method.

Remember to:

✔ Roll and join coils carefully and neatly.

✔ Give your pottery a special look. It might be graceful, humorous, or mysterious.

✔ Decorate your pottery with textures and patterns.

Vocabulary

English	Spanish
pottery	*cerámica*
coil method	*método espiral*
kiln	*horno*
firing	*encender*

Step 1: Plan and Practice

- Will you create a vase, a bowl, or a jar? What other forms might you consider? Look at the pictures on these pages for ideas.

- Practice making coils and joining them before you begin.

- Try out ways to make textured patterns in a piece of clay. These experiments will help you think about and get ideas for pottery.

Inspiration from Our World

Ⓑ Coils and clay dots

Inspiration from Art

 A

Karita Coffey, *Plains Indian Women's Leggings*, 1981. White earthenware.

Clay can be used to create objects that we use in daily life. Some artists use clay to create sculptures that make us think. These leggings made out of clay cannot be worn or worn out. They are hard and will last for a long time. What do they make you think about?

 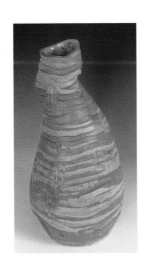

C A symmetrical coil pot **D** An irregular coil vessel

Step 2: Begin to Create

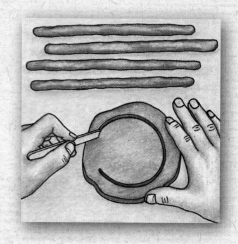

- Prepare a slip to join pieces of clay together. Slip is a creamy mixture of water, clay, and a few drops of vinegar.

- When you join two pieces of clay, you must score, or scratch, small ridges where the clay pieces will be joined. Then coat the scored area with slip.

- Make a base for your pottery from a slab of clay.

Press clay into a flat slab. Cut a shape for your base. Roll coils.

Step 3: Revise

- Did you blend the coils together?

- Did you give your container a special look?

- Did you make textures or patterns?

Step 4: Add Finishing Touches

- Allow your clay to dry before your teacher fires it in a kiln.

- After your clay is fired, you have several choices for finishing. You can leave it natural. You can paint it with watercolors and allow the colors to soak into the fired clay. You can paint it with bright acrylic paints. You can glaze it and fire it a second time.

Step 5: Share and Reflect

- Make up a title for your artwork.

- Discuss your work and the significance of its title with your classmates.

- What other forms would you like to create with the coil method?

Quick Tip

Keep a record of the process for making your clay object. What did you do and how did it affect the clay? How long did it take from start to finish?

Quick Tip

Artists will inscribe their initials on the bottom of their clay work before it dries. Or, they will paint their name on the bottom during the glazing process.

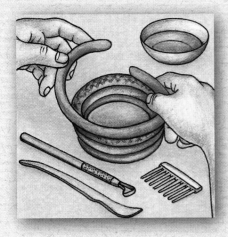
Bend and press coil to base. Add more coils.

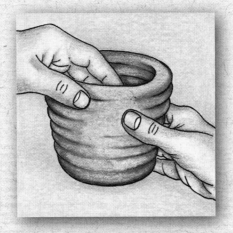
Blend the coils together on the inside. You can smooth the outside, too.

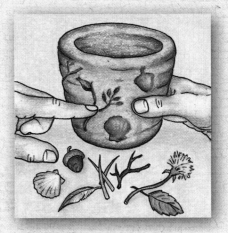
While the clay is still moist, you can press textures or patterns into it.

Art Criticism

A Student artwork

Describe
What do you see?

Analyze
How could you use this container?

Interpret
Is the container humorous, graceful, or mysterious? Explain your answer.

Evaluate
What are the best features of this particular piece of pottery?

Nature's Gifts
Living with Animals

In the Past

This figure of a bison was made more than 12,000 years ago. Historians refer to that time as the Stone Age. The artist carved the animal from a reindeer's antler. The carving was found in a cave in France. Notice the artist's skill in making curved lines.

Middle Stone Age,
Bison Licking Its Back,
ca. 15,000–10,000 BCE.
Bone.

In the Past

ca. 15,000–10,000 BCE

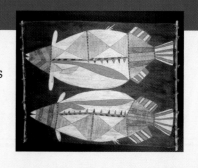

1900s

In Another Place

An artist in **Australia** painted these fish on a thin piece of tree bark. The artist made the paint from different colors of earth. Notice the patterns made with repeated straight lines.

Pacific Ocean

Australia

Southern Ocean

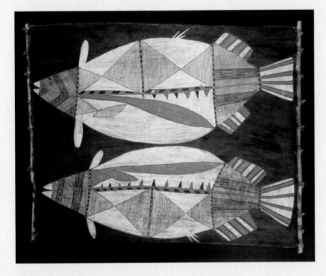

B Aboriginal painting, *Two Fish*, 1900s. Bark painting.

In Daily Life

Many people have aquariums or fish bowls in their homes. They are a way to bring nature indoors. Sometimes aquariums are also seen as artworks or decorations in public places. People enjoy looking at them.

In the Present

C

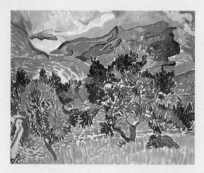

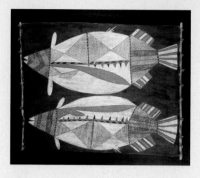

a b c d

Match each phrase to a picture.

1 an artwork made with clay
2 a painting on tree bark
3 a vessel made with natural materials
4 a landscape with a complementary color scheme

Write About Art

Robert Havell looked closely at birds in nature. He made sketches and notes in a journal. To help him remember what he saw, he would carefully describe the details of a creature in its environment. What do you think he might have written about the Great White Heron you see in Ⓐ?

Aesthetic Thinking

Artists who paint pictures of birds and animals are called wildlife artists. Some art galleries specialize in showing only work done by these artists. Do you think the work of wildlife artists should be exhibited apart from the work of other artists? Why or why not?

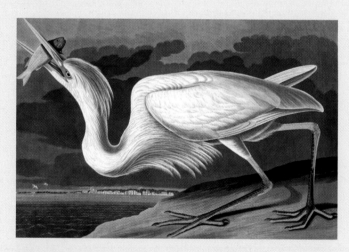

Ⓐ Robert Havell, Jr., *Great White Heron*, 1831–1838. Lithograph.

Art Criticism

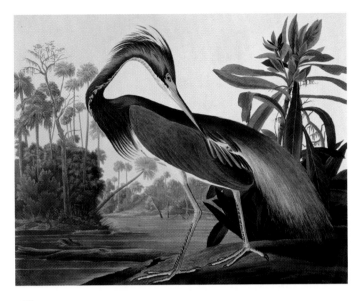

B John James Audubon, *The Blue Heron*, 1827.

Describe
What do you see in this artwork?

Analyze
What is the largest shape that you see? How much of the picture space does this shape fill?

Interpret
What purpose might this artwork serve?

Evaluate
What did the artist do especially well?

Meet John James Audubon

John James Audubon was born in Haiti in 1785 and soon moved to France. From an early age, he was very interested in birds, nature, and drawing. At the age of 18, he came to America. He traveled the country so that he could paint and write about all the birds he saw there. His book, *Birds of America*, includes 435 of his original paintings. Today, his name is associated with birds and bird conservation around the world.

Art History and Culture
When first published, in England, Audubon's Birds of America was a huge success. Due to the artist's skill at showing wildlife in natural settings, the book helped contribute to excitement about the wonders of life in frontier America.

Traditions
Our Artistic Heritage

A

Helen Hardin, *Recurrence of Spiritual Elements*, 1973. Etching and aquatint on paper.

What might you learn about this Native American artist's culture by looking at this artwork?

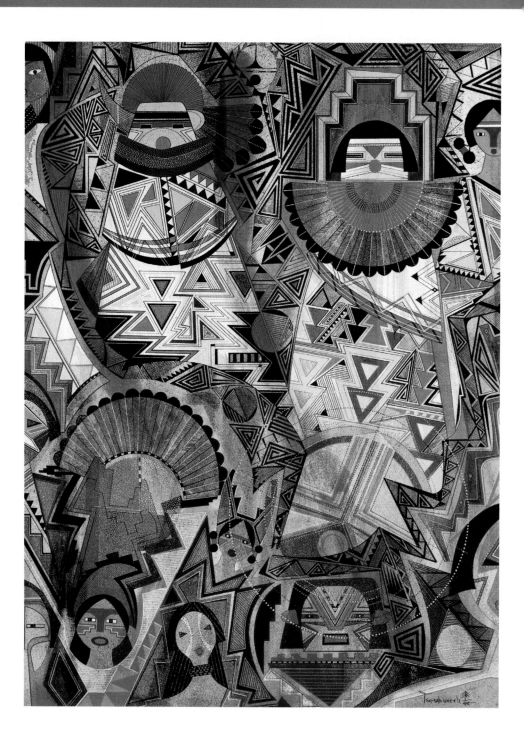

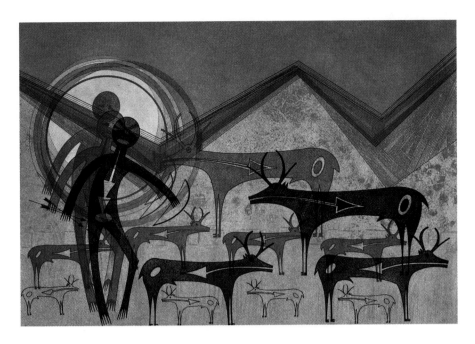

Helen Hardin, *Deerslayers Dream*, 1981. Etching and aquatint on paper.

What shapes are repeated throughout this artwork? What colors seem important?

Many people like to learn about the past. We can get new ideas and inspiration when we find out about life in other times and places. Artists also learn from the past and from other cultures. They study artistic traditions, or the customary ways of making artworks. When artists make artworks in traditional ways, we say that they are continuing a tradition.

Some artistic traditions are continued in the same way for hundreds of years. Sometimes artists change traditional ways of working. They create new purposes for traditional art forms.

Meet Helen Hardin

Helen Hardin began making paintings when she was a child. At the age of nine, she exhibited her paintings alongside those of her mother, who was a well-known artist. When she grew up, Helen signed her paintings by her Indian name, Tsa-Sah-Wee-Eh, or "Little Standing Spruce." In many of her paintings, she combined traditional Native American symbols and images with geometric forms and patterns.

A Tradition of Quilting

Long ago, people in Asia made quilts to keep warm. They sewed a layer of warm material between two layers of fabric. As the tradition of quilting spread around the world, quilt makers tried new ways to make the top layer of the quilt. One way to make a quilt top is to sew pieces of fabric together to make a large design.

Quilt artists often create patterns with positive and negative shapes. A positive shape stands out from the background. It has edges or colors that get your attention quickly. The positive shapes in Ⓐ create the main parts of the houses that are repeated in the quilt. Where are the negative shapes in Ⓐ and Ⓑ?

Vocabulary

English	Spanish
quilt	*edredón*
quilt block	*bloque de edredón*

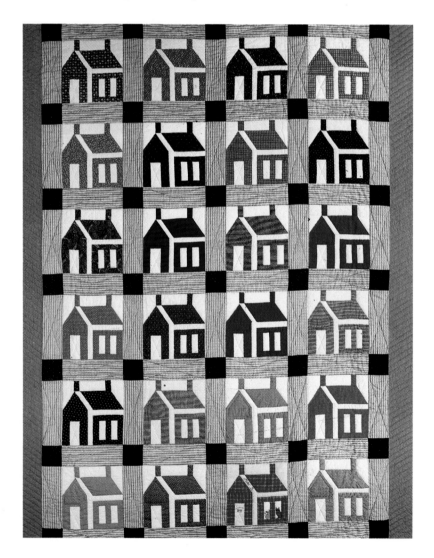

Ⓐ
Bette Nassar Clark, *Houses*, 1840–1860. Pieced cotton.

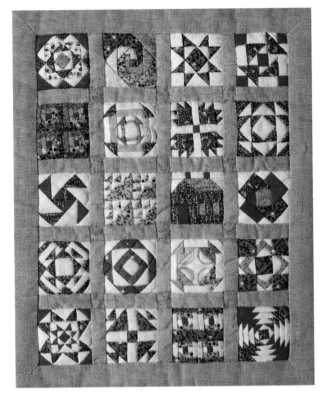

B Jessie Harrison, Mini blue sampler quilt.

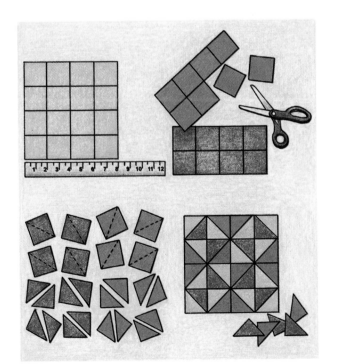

Design Squares

You can design a quilt block with positive and negative shapes. A quilt block is a square-shaped pattern repeated and combined to form a quilt top.

- Select a light-colored piece of construction paper, 8 by 8 inches, for your background.

- Use a ruler and pencil to draw sixteen 2-inch squares on your paper.

- Measure and cut two additional colors of construction paper into eight 2-inch squares.

- Cut all squares from corner to corner to form 16 triangles, 8 of each color.

- Arrange your triangles in different ways on your background paper.

- When you have a design that pleases you, glue the triangles to your background.

C Student artwork

A Tradition of Paper Cutting

In many places throughout the world, people have a tradition of paper cutting. Artists cut designs and pictures out of paper. They use scissors and other tools to cut out lines and shapes.

Paper cuttings are often used as gifts and decorations. The paper cutting in Ⓐ is part of a tradition that began in Germany. The paper cutting in Ⓑ was made in China.

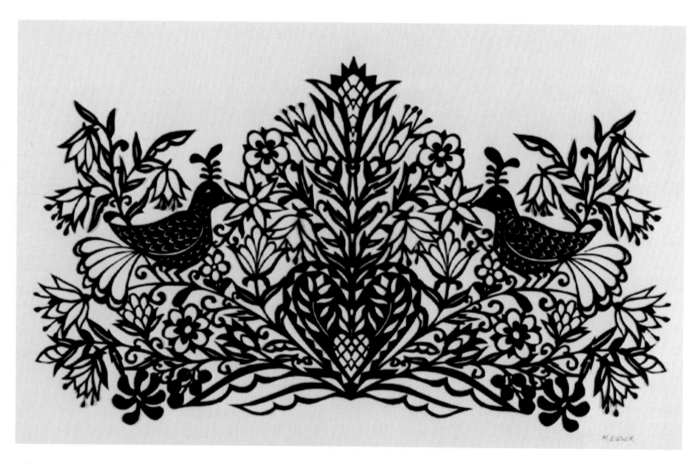

Ⓐ Marilyn Diener, *Lilies of the Field*. Paper cutting.

Vocabulary

English	Spanish
paper cutting	*recorte de papel*

B China, Paper cutting.

Some paper cuttings have symmetrical balance, such as what you see in A. If you imagine a line going from the top to the bottom in the middle of the cutting, you can see that both sides are the same. How did the artist create radial balance in B?

More on Paper Cutting

Paper cutting begins with a medium-weight paper and a pencil. The artist draws the design, then cuts it out with scissors and a razor blade. It can take from one to 100 hours to complete, depending on the design.

Symmetry in Design

You can make your own paper cutting with symmetrical balance.

- Fold a piece of paper in half.
- Draw one-half of a design on one of the folded sides.
- With a pencil, shade the negatives shapes that you will cut away.
- Make sure that all of the positive shapes are connected.
- With the paper still folded, cut through both layers.
- Carefully unfold your paper and glue it to a background paper.

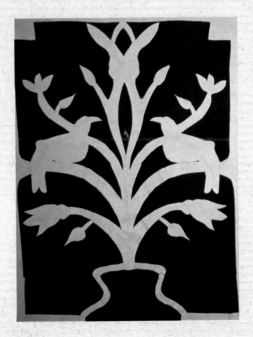

C Student artwork

Molas

A Cloth Tradition

Read, Look, and Learn

Among the Kuna people in Panama, there is a tradition of making brightly colored panels of cloth called molas. A mola is made from many layers of fabric. The artist cuts out shapes from the top layers to show the beautiful colored fabric below. Molas are made and worn by the Kuna women and girls. Their designs often feature local creatures, plants, scenes from community stories, and abstract designs.

You can make a paper mola.

Remember to:

✔ Feature a creature of your choice.

✔ Create a symmetrical design.

✔ Use at least five bright colors.

Vocabulary

English	Spanish
mola	*mola*

Computer Option

Find out how to use the cut and paste functions on your computer.

Step 1: Plan and Practice

• Look at the mola in **A** to see how its panel is filled with patterns and designs.

• What creature will you show on your paper mola? Look at **B**, **C**, and **D** for ideas.

• Create some sketches and choose your favorite.

• Select five different colors of paper. Which will be your background color?

Inspiration from Our World

 B

Inspiration from Art

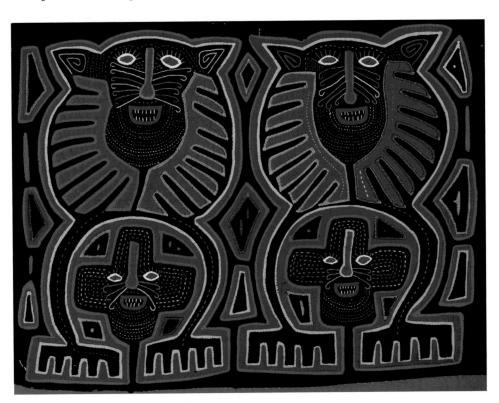

A

Unknown, Mola.

What creatures are featured in this mola? How many different layers of fabric do you see? What makes this design symmetrical or asymmetrical?

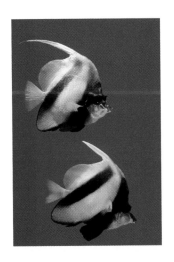

C

D

Step 2: Begin to Create

- Fold a piece of colored paper in half.

- Decide where you will make your drawing.

- What creature shape will you draw on the folded paper?

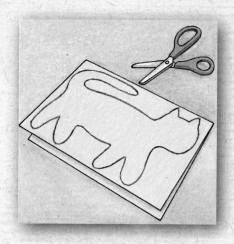

Step 3: Revise

- Show your design to a classmate. Can your classmate identify the creature you have created?

- What changes should you make?

- Have you created a symmetrical design?

- Did you include at least five different bright colors?

Draw the shape of a creature on a folded paper. Cut out the folded paper to make two identical pieces.

Step 4: Add Finishing Touches

- Stand back and look at your paper mola.

- Have you filled your paper?

- Should you add more stacked shapes or details?

Step 5: Share and Reflect

- Display your paper mola with those of your classmates.

- How many different kinds of animals or creatures did your class create?

- What differences do you notice among the many completed paper molas? How are they similar?

- If you made another mola to go with this one, how would it be different?

Sketchbook Connection
Practice using positive and negative shapes by drawing shapes and filling them with dark and light colors in your sketchbook. You may want to use your sketches to design a T-shirt.

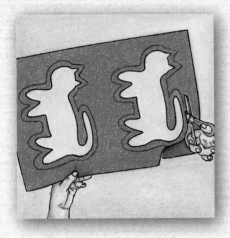

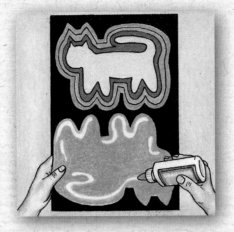

Glue both pieces to colored paper. Cut, leaving a border of the second color. Repeat two more times. Use a different color each time.

Glue the completed shapes to another piece of paper, leaving some space between the shapes.

Add stacked shapes and details inside the main shapes and in the background.

Art Criticism

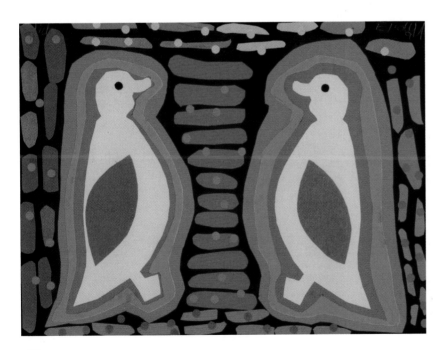

A Student artwork

Describe
What animal did the artist feature?

Analyze
How did the artist create symmetrical balance?

Interpret
What mood or feeling does the mola suggest?

Evaluate
What did the artist do especially well?

Weaving Bands of Cloth

Thousands of years ago, people learned to weave cloth, or fabrics. Fabrics are made up of many threads or yarns woven together.

To weave, a weaver places yarn over and under other yarns. Many weavers use a loom, or frame, to hold one set of yarns.

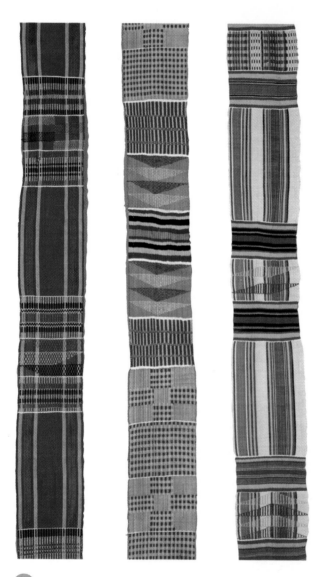

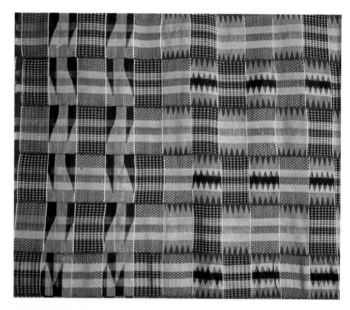

B *Kente Cloth, Silk.* Asante peoples, Ghana.

A *Three Kente Cloth Strips, 1941–1943.* Asante peoples, Ghana.

Weaving traditions can be different from one culture to another. The fabric strips in Ⓐ are kente cloth strips woven by the Asante people in Ghana, Africa. The kente cloth in Ⓑ is made from narrow bands of cloth that are stitched together. Kente cloth was first made for African chiefs of the Asante Kingdom about 300 years ago.

Using a Straw Loom

You can weave a sash, headband, bracelet, or necklace.
Use a straw loom and follow the instructions.

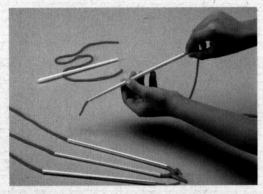

1. Cut five pieces of yarn. Push each yarn through a straw and tie a thick knot at one end.

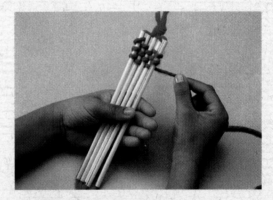

2. Tie the other ends together in one big knot. Use a long piece of yarn. Weave over and under.

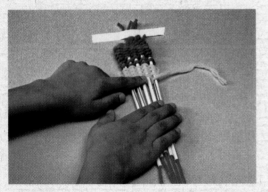

3. Push the weaving up toward the big knot. Pull the straws down.

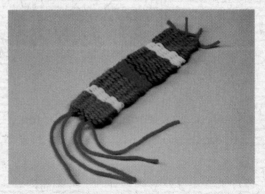

4. Cut the knots and remove the straws. Tie the loose ends of yarn together.

Designs on Fabric

People around the world have traditions for decorating cloth. Batik is a traditional process that uses wax and dye to make pictures or patterns on cloth. Dye is a colored liquid that stains cloth. Javanese artists made the batik in **A**.

Look at the batiks in **B** and **C**. The white areas show the color of the cloth before it was dyed. All of the white areas, or negative spaces, were covered with wax. The wax kept the dye from staining the white cloth.

B Robin Paris, *Box Beetle*. Batik painting.

A Java, Detail of design on a batik sarong, ca. 1920. Glazed cotton.

C Jane Maru, *Our Lady of Justice*. Batik painting.

All of the colored areas, or positive shapes, in the batiks were dyed. The batiks were waxed and dyed many times to create the rich layers of color.

Change in Tradition

You can create a batik-like design on white cloth. Instead of wax, you can use toothpaste mixed with hand lotion. You can use acrylic paint instead of dye.

- Plan a simple design.
- Brush the toothpaste mixture on the cloth where you want white lines or negative spaces. Let the cloth dry overnight.
- With a sponge brush, gently apply diluted acrylic paint over the whole cloth. Allow the paint to dry overnight.
- Rinse cloth under running water.

D Student artwork

Embroidery
A Story in Stitches

Materials you will need
- burlap or other cloth
- assorted yarns
- needle

Read, Look, and Learn

Did you know that you can use a needle and thread to create an artwork? An artwork you create by sewing, or stitching, is stitchery. Artists who make stitchery must work slowly and carefully. They use many different yarns and threads.

Artists select colors. They also choose yarns or threads. The stitches they make can be long or short. Stitches can be used for lines and to outline shapes. Stitches close together can be used to fill in a shape.

You can create a picture using stitchery. Choose what you will show, and what colors, yarns, and threads you will use.

Remember to:

✔ Make a picture of a story or event from the past.

✔ Use different kinds and colors of stitches.

✔ Use stitches to make lines and outlines, and to fill in shapes.

Step 1: Plan and Practice

- You can practice making different stitches on a scrap of cloth.
- Make short and long stitches.
- Try putting stitches close together.
- Choose an animal or another idea for your work.
- Make sketches.

Vocabulary

English	Spanish
stitchery	*pespunteado*

Inspiration from Our World

Inspiration from Art

A Mildred Johnstone with Pablo Burchard, *Alice in a Wonderland of Steel*, 1949. Weaving.

Artist Mildred Johnstone's husband worked for a big steel company. This stitchery picture shows her as Alice in what she called a "Wonderland of Steel." How did Mildred use stitches to show the parts of the big steel mill? How did she use stitches as outlines?

C

D

Step 2: Begin to Create ⟶

- Choose one of your sketches for your stitchery.
- Plan the main shapes and lines of your picture.
- Draw these lightly on your cloth.

Sketch a picture.

Step 3: Revise

- Have you used more than one color?
- Have you made different kinds of stitches?
- Where can you use stitches to fill in a shape?
- How did you use stitches to make outlines?

Step 4: Add Finishing Touches

- After you complete the stitching, you might add some other materials, such as buttons, beads, or pieces of ribbon.
- How will you display your stitchery? Will you attach it to a strip of wood?

Step 5: Share and Reflect

- Show your stitchery picture to one of your classmates.
- Tell your classmate about the choices you made when you created your stitched picture. Why did you choose the colors of yarn?
- Why did you make short and long stitches?
- Where did you use stitches close together?
- Did you choose to add other materials? Why or why not?

> **Sketchbook Connection**
> Sketch some ideas for different patterns you can stitch. How would you sew a star?

Draw main shapes and lines onto cloth.

Use a large needle and yarn to stitch over lines.

End the last stitch on the back. Loop yarn through the other threads on back before cutting.

Art Criticism

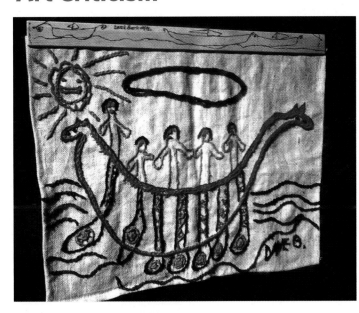

(A) Student artwork

Describe

What do you see in this stitched picture?

Analyze

Where did the artist use long and short stitches? What other kinds of stitches were used?

Interpret

If you could frame this stitchery and hang it in a room, where would you put it? Why?

Evaluate

How carefully did this artist work? Explain your answer.

A Puppet Tradition

Vocabulary

English	Spanish
shadow puppet	*títere a contraluz*
profile	*perfil*

Shadow puppets are a tradition in many countries such as Indonesia, Turkey, India, and Greece. People use the puppets to tell their favorite stories and to celebrate special events such as birthdays.

Indonesian puppets are traditionally made from stiff paper or animal hides. They also can be made from plastic, cardboard, or thin metal. Shadow puppets can be very small—about 12 inches—or life-size.

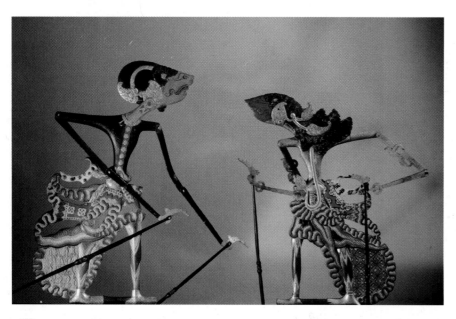

Ⓐ Java, *Wooden Wayang Shadow Puppet*, ca. 1800. Wood and paint.

Ⓑ Puppet from a Thai Buddhist drama.

Most shadow puppets show the head in profile, or side view. The puppets are held so that they cast a shadow on a white sheet.

A large stick supports the main body shape. A pair of smaller rods controls the arm movements.

Studio Time

Shadow Puppets

You can make a shadow puppet of a character in a story.

- Make a pattern by drawing an outline of your character with the head in profile.
- Make each arm in two parts so that it can bend at the elbow.
- Trace patterns onto white poster board.
- Use markers to add color and details to your puppet character.
- Carefully cut out the figure and the four arm pieces. Attach the arms with paper fasteners.
- Glue an 18-inch wooden dowel down the center of the puppet's back and attach straightened coat hangers to the hands with fishing line, carpet thread, or duct tape.

C Student artwork

A Tradition of Masks

People in many lands create masks. Masks are a kind of sculpture. Masks and sculpture are three-dimensional art. They have height, width, and depth. Artists make masks from wood, clay, and other materials.

Vocabulary

English	Spanish
masks	*máscaras*
three-dimensional	*tridimensional*

Long ago, actors in Greece wore masks like the ones in **A** and **B** to represent different characters in plays. In many countries, the tradition of actors wearing masks is still popular. Because of this tradition, the mask has become a symbol for acting and the theater.

A Various theatrical masks, 600–500 BCE. Terra-cotta.

B Wendy Gough of Arlecchina's Masks, Contemporary Greek Theater Masks.

Mask Design

You can create a mask from paper. Learn to change the flat paper into a three-dimensional form. Study the ways to shape paper in .

1 Think of a shape for the mask. Draw it.

2 Cut out the shape. Add a cut at the bottom.

3 Overlap the paper and glue it down.

4 Your mask will be three-dimensional.

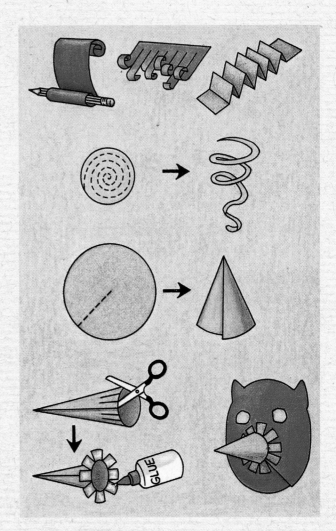

C

D

Student artwork

Papier-Mâché Masks
Celebration Traditions

Materials you will need
- newspaper
- wheat paste or liquid starch
- balloons
- masking tape
- tempera paint
- paintbrushes
- scrap materials, such as ribbons and yarn

Read, Look, and Learn

Masks are used for celebrations and parades in many cultures around the world. Animals are a common theme because they often symbolize important beliefs in a culture. They might be symbols for such things as good luck, wealth, or happiness.

Artists make masks out of many different materials such as wood, paper, or cloth. Because people want the masks they wear to be lightweight, they often use papier-mâché. In this process, the artist builds up layers of paste-coated paper on an armature, or support, to create a form. At least five or six layers of paper strips or torn bits of paper are used. When the paste-soaked paper dries, the form is sturdy and can be painted.

You can make a papier-mâché mask that could be used for a celebration or parade.

Remember to:

✔ Create special animal features for your mask.

✔ Make it bright and colorful.

✔ Add decorative details to make it festive or fancy.

Step 1: Plan and Practice

- Look at the images of animal heads and faces on these pages.

- Research animal symbolism in other cultures.

- Choose an animal and make some sketches for your mask.

Vocabulary

English	Spanish
papier-mâché	*papel-maché*
armature	*armazón*

Inspiration from Our World

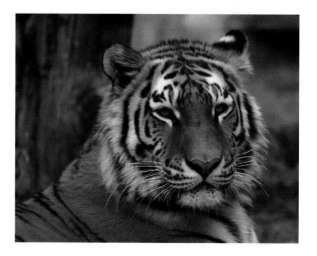

B Tiger

144

Inspiration from Art

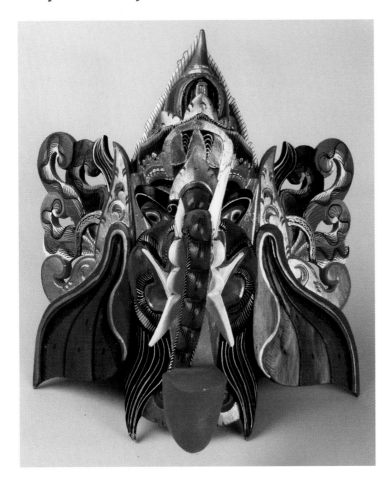

 A

This mask was made in China for use in celebrations. The elephant is very important in the beliefs of some people in China and other parts of the world. What details did the artist add to make the mask festive?

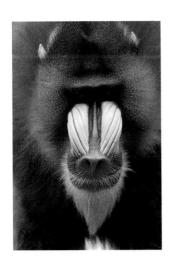

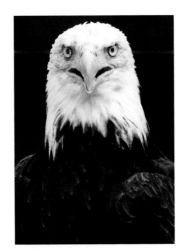

C Mandrill

D Bald eagle

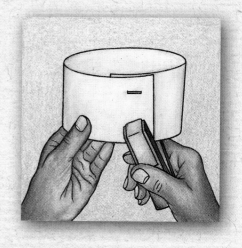

Make a paper collar.

Step 2: Begin to Create

• Prepare your papier-mâché materials.

• Make your mask armature from a balloon held in a paper collar.

Step 3: Revise

• Did you show some special animal features?

• How can you make your mask bright and colorful?

• What details can you add?

Step 4: Add Finishing Touches

• What materials can you use to make your mask festive or fancy?

• Attach two pieces of heavy ribbon or string to hold your mask in place.

Step 5: Share and Reflect

• Make up a folktale and write a short paragraph about your animal mask.

• Share your mask and story with your classmates.

Sketchbook Connection
Sketch ideas for masks with different expressions.

Quick Tip
Remember to cut out holes in your mask for the eyes and nose. Make sure the mask is dry first.

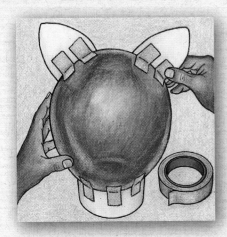
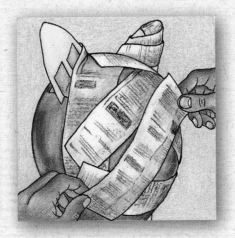
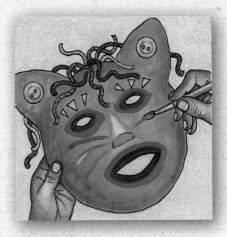

Tape the collar and special parts such as ears, eyes, and mouth to the balloon.

Build up layers of papier-mâché around the front part of the balloon. Allow it to dry. Pop the balloon.

Add more details. Paint and decorate with buttons, yarn, or other trims.

Art Criticism

A Student artwork

Describe
What animal is shown? What real features do you see?

Analyze
What decorative features are added? What is different or changed?

Interpret
What makes the mask seem festive or fun? Why?

Evaluate
What did the artist do especially well?

Traditions
Special Events

In the Past

Theater was an important part of life in ancient Greece. One of the favorite characters in Greek drama was Dionysos. Actors would wear clay masks to portray him in comedies. Mask making became an art form within the larger art form of Greek theater. Some masks were created for people in the audience to take home as souvenirs. They would use them to decorate their walls.

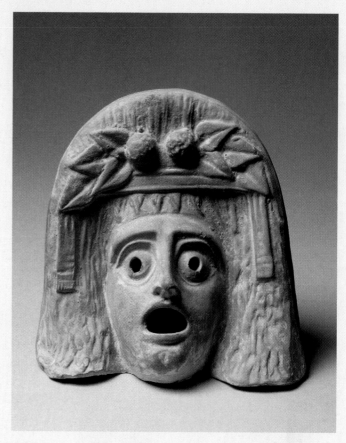

A Greece, *Mask of Dionysos*, 200–100 BCE. Terra-cotta.

In the Past

200–100 BCE

ca. 1900s

In Another Place

This bush buffalo mask was created about 100 years ago in a part of **West Africa** that is today called Burkina Faso. It is carved from wood, painted with natural pigments, and decorated with dried grass. Dancers would wear these masks during harvest celebrations and at ceremonies during the dry season. People liked the bush buffalo because they believed it protected their community.

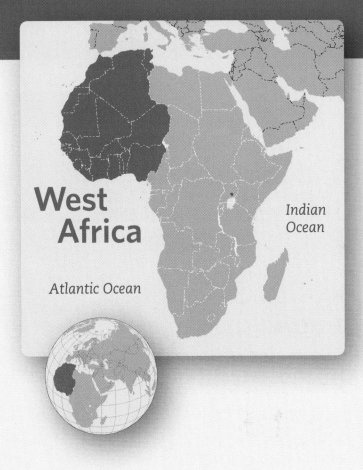

West Africa

Atlantic Ocean

Indian Ocean

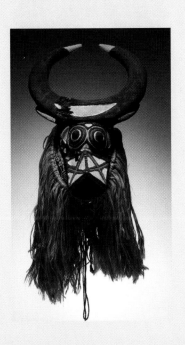

B Burkina Faso, *Bush Buffalo Mask*, ca. 1900. Wood and fibers.

In Daily Life

People who play sports often wear masks for protection. What other ways do people use masks?

In the Present

C

a

b

c

d

Match each phrase to a picture.

1 kente cloth
2 a design with radial balance
3 a batik
4 a mola

Write About Art

Write five sentences that tell about things you see in the paper cutting by Jeri Landers in **A**. Each sentence should describe something that an animal is doing.

Aesthetic Thinking

You can get ideas from artworks as well as the world around you. You also should be original and not copy. What do you think is the difference between copying and getting ideas?

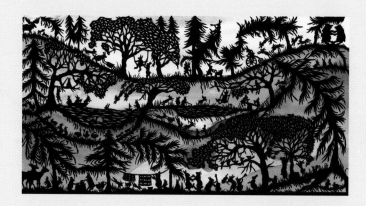

A Jeri Landers, *Grasshoppers of Hopalong Hollow*, 2005. Paper cutting.

Art Criticism

B Keisuke Serizawa, *Mingei*. 1950–1975. Stencil print.

Describe
What things do you recognize in this stencil print?

Analyze
Where are shapes repeated? How did the artist balance this design?

Interpret
Why (or why not) might the following words seem appropriate for this artwork: delicate, lacy, active, happy, fun?

Evaluate
Why do you think this artist was named a "national treasure"?

Art History and Culture
Paper cutting requires only paper, pencil, and cutting tools. These tools are cheap and readily available. It is an art form that everyone can try.

Portfolio Tip
Fiber arts take time and often require delicate handling of the materials. This art form asks you to learn patience!

Meet Keisuke Serizawa

In 1956, Keisuke Serizawa was given the title "Living National Art Treasure of Japan." He was a master of cutting stencils for decorating fabric, paper, book covers, fans, and many other beautiful household items. As a "national treasure," he was paid by the Japanese government to train other artists to carry on the tradition of cutting stencils.

Imagination
Invention and Abstraction

A

Elizabeth Murray, *Painter's Progress*, 1991. Oil painting.

What objects do you recognize in this artwork? How is this painting like a sculpture?

Elizabeth Murray, *Worm's Eye*, 2002.
Oil painting.

How do these figures look
like cartoons?

Have you ever looked at a tree or a cloud and imagined that you saw something else? We might see the face of a person in the trunk of a tree, or a cloud might look like a dragon. Sometimes our eyes play tricks on us. Things are not always as they seem.

Artists challenge us to look at things in new ways. They want us to think about new ideas. Some artists emphasize the humor or strangeness in the world they see. Sometimes, they surprise us with what they show and how they show it.

Meet Elizabeth Murray
Elizabeth Murray was born in Chicago, Illinois. Her paintings are often playful arrangements of common objects, cartoon-like figures, and odd shapes. Sometimes she chooses bold colors and lines that show movement.

Imagining the Impossible

Vocabulary

English Spanish

imagination *imaginación*

Imagination helps you think about things in a new or different way. There are many ways to use your imagination for artwork. One way to use your imagination is to combine ideas that seem to be very different.

What ideas did the artist combine in the sculpture in Ⓐ? What ideas did the artist combine in his drawing of a "mechanimal" in Ⓑ? Why do you think he called it a mechanimal?

Ⓐ Pablo Picasso, *Baboon and Young*, 1951. Bronze sculpture.

Ⓑ Murray Tinkelman, *Mechanimal: Diesel-Driven Guppy*, 1979. Pen and ink.

About the Artist

Spanish painter and sculptor Pablo Picasso was the son of an artist. In his artworks, such as *Baboon and Young*, he often explored unusual combinations and imagined new ways of seeing.

C Wanda Gag, *Stone Crusher*, 1929. Lithograph print.

How did the artist who made C use her imagination? How are machines and animals different? How are nature's creatures and machines alike?

Mechanicreature

Create a drawing of a "mechanicreature."

- Combine parts of machines and creatures.
- Make a list of ordinary machines such as lawnmowers, tractors, cars, trains, and so forth.
- List different kinds of animals, fish, birds, and insects.
- Choose one item from each list and combine the two to make your drawing.
- Draw an environment for your mechanicreature, showing where it lives and how it works or feeds itself. Make up a name for your mechanicreature.

D Student artwork

Using Materials Inventively

The sculpture in Ⓐ was created by Patricia Renick. She built the sculpture around the body of a real car. The artist's first idea for this artwork is shown in Ⓑ. She added oil-based clay to a toy car. This kind of maquette, or small model, is often used to plan a very large sculpture.

In Ⓒ, you see the real car. It is held up by an armature, or support, made of steel. Picture Ⓒ also shows how the artist glued Styrofoam to the armature and the car.

Ⓐ Patricia. A. Renick, *Stegowagenvolkssaurus*, 1974. Steel and fiberglass sculpture.

Ⓑ Patricia A. Renick, maquette for *Stegowagenvolkssaurus*.

Ⓒ

In , you see the artist adding clay to the Styrofoam and carving it. The clay was covered with fiberglass to create the final work. The title is *Stegowagenvolkssaurus*.

D

About the Artist

Florida-born Patricia A. Renick used fiberglass and salvaged machine parts to make both playful and serious sculptures. Sometimes she worked with raw steel. Her dinosaur and car combination implies that—like the dinosaur—the car will also be extinct in the future.

Creative Combos

You can make a clay sculpture that combines the forms of three things in an unexpected and imaginative way. Think about how you might combine a plant, an animal, and a nonliving thing such as a ball or an airplane, for example.

- Use slip when joining clay parts.
- Add textures, patterns, and details.
- Think about how your sculpture will be seen from all sides.

E Student artwork

Materials you will need
- assorted found objects
- glue
- tape

Assemblage
Dumpster Dragons

Read, Look, and Learn

Sculptures can be created from scrap materials and objects people discard. Some artists have focused on making sculpture from a variety of recycled objects and materials. A sculpture created by joining objects is called an assemblage. To make an assemblage, artists find and collect objects with interesting forms, textures, and meanings.

You can collect and assemble some objects to create a sculpture. It might be a robot, a dragon, or a dog. Look for broken toys, clocks, and other small objects. Save empty boxes, tubes, bottle caps, and buttons.

Remember to:

✔ Use your imagination to combine objects.

✔ Attach all parts so that they stay together.

✔ Make careful choices when unifying your sculpture with colors and details.

Step 1: Plan and Practice

- Hold different objects in several positions to get ideas for your sculpture.

- Remember that the lettering or colors on recycled objects can become part of your design.

- Look at the pictures on these pages for ideas.

Inspiration from Our World

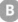 **B**

Vocabulary	
English	Spanish
assemblage	*ensamblaje*

Inspiration from Art

A

Leo Sewell, *Stegosaurus*. Sculpture.

Leo Sewell uses objects he finds to create sculptures. Which objects in this sculpture look familiar to you? When he chooses objects, he thinks about colors, shapes, textures, and how long they will last.

C

D

Step 2: Begin to Create ———————————▶

- Gather the materials and tools that you will need.
- Do you need to bend, cut, or reshape any of your collected objects?

Choose objects for the body of your dragon.

Step 3: Revise

- Are you pleased with the way you combined different objects?
- Did you attach all parts so that they stay together?
- Did you make careful choices when adding colors and details?

Step 4: Add Finishing Touches

- Colors, small forms, and patterns can add interest.
- What more can you do to unify your sculpture?

Step 5: Share and Reflect

- Give your assemblage a name.
- Display your work along with those made by your classmates.
- Discuss the problems you had to solve in making your sculpture.

Portfolio Tip

You can take a photo of your assemblage for your portfolio. Always remember to write your name, the title of the work, and the date on the back.

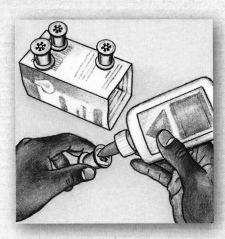

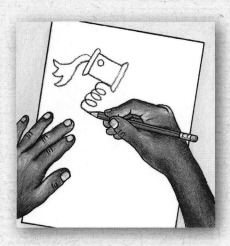

Attach parts of the dragon with glue. Secure with tape to assure a tight bond.

Add details with colored paper, yarn, wire, feathers, foil, and plastic spoons or forks.

Draw your assemblage with pencil.

Art Criticism

Describe
What materials did the artist use?
What is represented?

Analyze
Where do you see repeated parts?
How did the artist unify the sculpture?

Interpret
Does this sculpture seem friendly?
Why or why not? What words can you use to describe its expression?

Evaluate
Does this assemblage appear to be sturdy and well constructed? Why or why not?

Ⓐ Student artwork

Making Things Look Real

Vocabulary

English	Spanish
shading	*sombrado*

When artists want to make things look real, they study the light and the shadows of the things they see. Light and shadows help us to know if an object is flat or round, smooth or rough. Look at the realistic tree in Ⓐ. Where are the lightest and darkest areas? Notice the gradual changes from light to dark.

Now look at the rough texture of the bark. The texture comes from small patches of shadow that you can see on the bark. The shadows create a feeling of roughness.

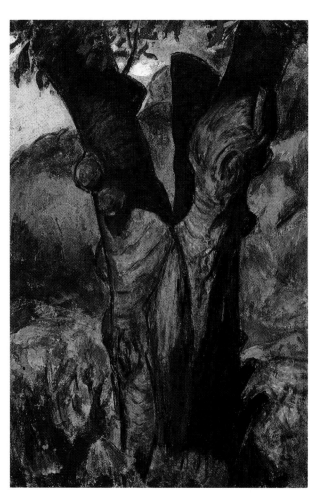

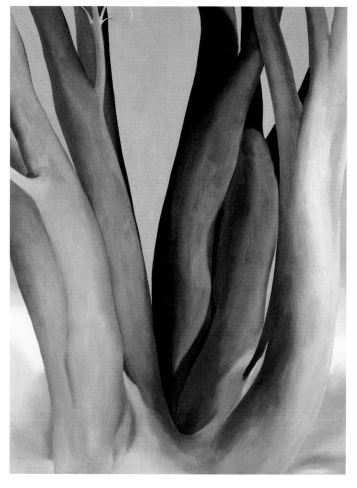

Ⓐ Alfred Maurer, *Old Tree*, 1924. Oil painting.

Ⓑ Georgia O'Keeffe, *Dark Tree Trunks*, 1946. Oil painting.

C

Picture B shows a painting of a tree. The artist has shaded the tree bark so it looks very smooth. How does this shading, or very gradual changes in value from light to dark, help you know the trunk forms are round?

Artists use several methods to suggest value and texture in their artworks. The five trees in C are shaded in different ways. Why are all the trees darker on one side and lighter on the other?

Studio Time

Real Trees

Try different ways to draw and shade a tree so the form stands out. Experiment with ways to show textures.

- Draw a tree using different values of light and dark to show shading and texture.

- Where will the light source be? Remember that a light source, like the sun, creates areas of light and shadows. Use light values wherever the light falls. Use dark values to show shadows.

- Experiment with different types of textures. How can you show a very smooth texture? How can you use lines and shading to make a rough, knobby texture?

D Student artwork

Changing Appearances

Vocabulary

English	Spanish
exaggeration	*exageración*
distortion	*distorsión*

When artists show the beauty of trees, they sometimes create unique artworks. How are the trees in Ⓐ and Ⓑ unique or different? Artists usually get ideas by observing the world around them. Then they think about ways to emphasize certain lines, shapes, colors, and textures. They do not always try to create a realistic likeness of something.

Sometimes an artist might exaggerate, or change, the size of some parts of an artwork. In Ⓐ, you can see how Keisuke Serizawa exaggerated the size of the leaves compared to the size of the tree.

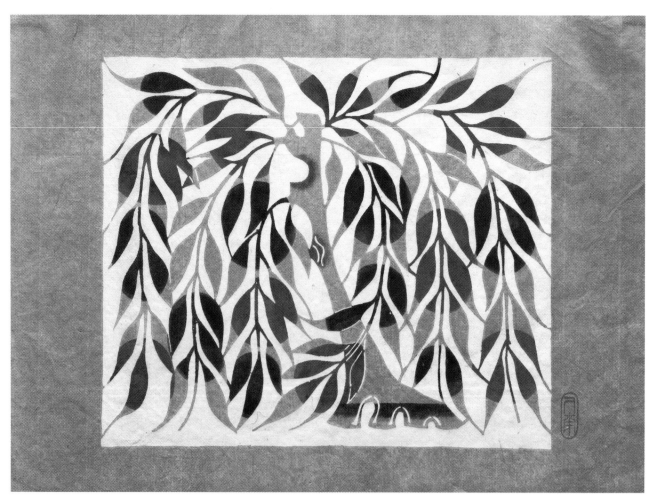

Ⓐ Keisuke Serizawa, *Tree of Life*, 1950–1975. Stencil print.

Unique Trees

You can change the look of a tree. Make a colored pencil drawing. Find your own way to express the beauty of a tree in a unique design.

- You can combine geometric shapes with organic shapes.

- You can transform the branches into lines that are loose and sweeping, or tight and angular.

- You can substitute bold line patterns for the realistic texture of the tree's bark.

C

Student artwork

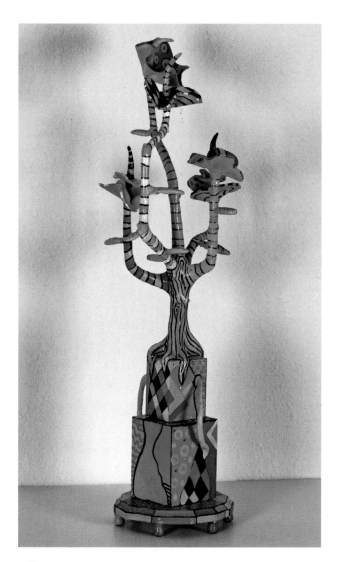

B David Robertson, *Happy Town Tree.* Paper on clay.

An artist may also distort, or change, the shape of a form. To create the sculpture of the tree in **B**, David Robertson left out details.

Materials you will need
- tempera paint
- brushes
- paper

Abstract Trees
Keeping It Simple

Read, Look, and Learn

The painting of a tree in Ⓐ has an abstract style. An artist working in an abstract style usually observes or remembers something real. Abstract means the artist invents shapes, colors, and lines instead of trying to paint a realistic likeness.

You can explore painting in an abstract style.

Remember to:

✔ Base your painting on sketches of real trees.

✔ Simplify the shapes and lines found in your realistic sketches.

✔ Create a color scheme that is not realistic.

Vocabulary

English	Spanish
abstract	*abstracto*

Step 1: Plan and Practice

- Begin with a realistic sketch of a tree.
- Put thin paper over your realistic sketch.
- Redraw some parts but change or omit some of the lines or shapes to make your drawing abstract.
- Look at the pictures on these pages for ideas.

Inspiration from Our World

 B

Inspiration from Art

Herbert Bayer, *The Tree*, 1931. Oil and collage.

Herbert Bayer was a graphic designer who also created abstract and surrealist paintings and collages. How can you tell that this is a tree? What kinds of shapes do you see?

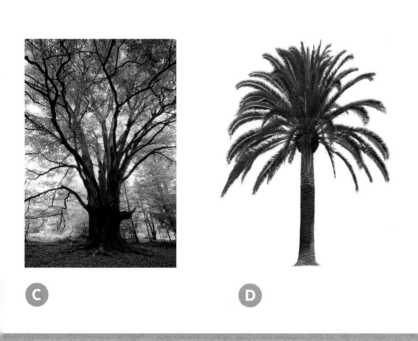

C

D

Step 2: Begin to Create →

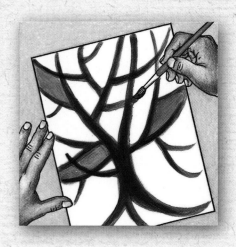

Begin with large areas and light colors.

- Will your painting be horizontal or vertical?
- Choose which colors to use first.
- Think about the brushstrokes you will use.
- Decide if you will blend colors or keep them separate.

Step 3: Revise

- Did you simplify the shapes and lines from a realistic sketch?
- Is your painting in an abstract style?
- Do your color choices add to the abstract style?

Step 4: Add Finishing Touches

- Stand back and look at your painting.
- What parts did you exaggerate or distort?
- Do you need to add or take away colors, lines, or shapes to help unify your painting?

Step 5: Share and Reflect

- Display your painting along with your sketches.
- Talk with your classmates about the process of abstraction.
- Is this a way of working that you would choose to do again? Why or why not?

Sketchbook Connection
Use your imagination to draw a tree. Then go outside and draw a tree you see. How are the drawings different?

Portfolio Tip
Make sure your painting is completely dry before you put it in your portfolio.

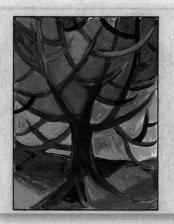

Continue with colors in other areas of the painting.

Wash, wipe, and blot the brush as you paint.

Add details last.

Art Criticism

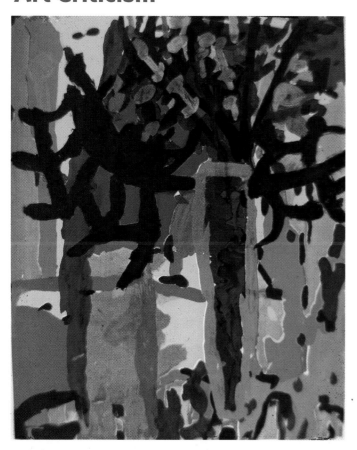

A Student artwork

Describe
What shapes and details do you see in this artwork? What colors do you see?

Analyze
What did the artist do to make this artwork seem more abstract than real?

Interpret
If you were going to give this artwork a title that would suggest the main idea, what would it be?

Evaluate
What did the artist do especially well? Explain your answer.

Thinking Differently

Vocabulary

English Spanish

nonobjective *sin objecto*

Some abstract artworks are called nonobjective art. Nonobjective means that no objects can be recognized. You see only lines, shapes, and other design elements.

Artists say that lines and shapes can send "wordless" messages or feelings to people. For example, vertical lines remind people of things that reach up. Horizontal lines remind people of calm, quiet feelings. In **A**, the irregular lines and shapes seem to wiggle. What ideas about motion seem to go with this artwork?

What kinds of motions or messages come from the artwork in **B**? What messages might people get from an artwork with many diagonal and zigzag lines? Why?

A Elizabeth Murray, *Wiggle Manhattan*, 1992. Lithograph print.

B Piet Mondrian, *Broadway Boogie Woogie*, 1942–1943. Oil on canvas.

C

D

Wordless Message

Try this experiment:

- Create a nonobjective artwork with either curved lines and shapes as in **C** or straight lines and shapes as in **D**.

- Draw several large shapes first.

- Add more shapes and lines to create a feeling of motion or another "wordless" message. Add colors that help to express the message.

E Student artwork

Differences in Styles

Artists have their own styles of painting. You can see these differences in the two still life paintings in **A** and **B**. Both paintings show objects on display. One still life painting has an abstract style. The other has a realistic style.

Picture **A** has many shapes and colors that fit together like a puzzle. Dark lines create patterns. Many shapes are outlined in dark colors.

A

Amelia Pelaez del Casal, *Fishes*, 1943. Oil painting.

About the Artist

Cuban painter Amelia Pelaez del Casal began painting romantic landscapes and later joined the avant garde movement of the 1920s. Her abstract works use bold colors and patterns.

B
Gustave
Caillebotte,
*Fruit Displayed
on a Stand*,
ca. 1881–1882.
Oil painting.

Shadows help to make **B** look realistic. Most likely, the artist painted the lightest shapes first. When you make choices about such things as colors, brushstrokes, light, and shadows, you are deciding the style of your painting.

Studio Time

Food on the Table

You can create a still life painting about food in a style of your choice.

- Choose some foods for your painting.
- Set up several still lifes with food.
- Make choices about colors, brushstrokes, light, and shadows.

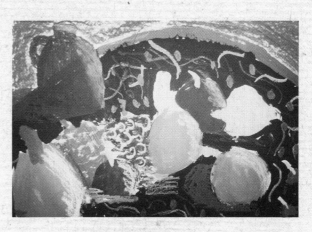

C Student artwork

Pop Art Style
Uncommonly Common

Materials you will need
- paper, cardboard, or found objects for creating basic forms
- masking tape
- papier-mâché materials
- tempera or acrylic paint
- brushes

Read, Look, and Learn

Some artists create art based on popular culture. Popular culture includes many things people see, buy in stores, or use everyday. In Pop Art, or popular art, artists get ideas by studying everyday advertising, manufactured objects, and food. In the sculpture in Ⓐ, the artist studied the form and proportions of cheeseburgers.

Pop art sculptures usually look like real objects. An artist also might exaggerate the size to make objects larger than they are in real life.

You can create a sculpture of something you see or use every day. It might be a tool such as a crayon or a pencil, or a food such as a sandwich or a pizza.

Remember to:

✔ Pay attention to form and proportion.

✔ Exaggerate the size or scale of your sculpture.

✔ Make some parts of it seem real.

Vocabulary

English	Spanish
Pop Art	*arte popular*

Step 1: Plan and Practice

- Look at the pictures on these pages for ideas from popular culture.

- Make some sketches.

- Imagine how you might create the basic form of the popular culture object.

- Experiment with folded paper, cut cardboard, or found objects.

Inspiration from Our World

Ⓑ Crayons

Inspiration from Art

A Claes Oldenburg, *Two Giant Cheeseburgers with Everything*, 1962. Sculpture.

Claes Oldenburg used wire screen to form these cheeseburgers. He covered the screen with cloth dipped in plaster. How did he show the different parts of the cheeseburger? How is this sculpture similar to real cheeseburgers? How is it different?

C Piece of cake

D Ice cream cone

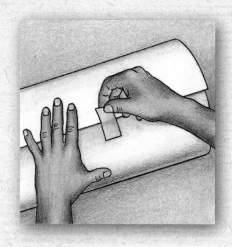

Step 2: Begin to Create

- Gather the materials you will need.
- Refer to your sketches as you work.

Step 3: Revise

- Are the forms and proportions of your sculpture like those of the object?
- What parts are the most realistic?
- Did you exaggerate size or scale?

Assemble your basic form.

Step 4: Add Finishing Touches

- Apply paint with care and attention to detail.
- What other details or parts can you add?

Step 5: Share and Reflect

- Display your artwork along with those made by your classmates.
- Explain how your sculpture is similar to the actual object. Tell how it is different.

Sketchbook Connection
Find some grocery store products in your kitchen. Select a product to sketch. What do you notice about the color and lettering on the packaging?

Quick Tip
If you had to make multiple copies of your Pop Art work, how would you do it?

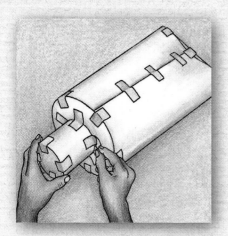

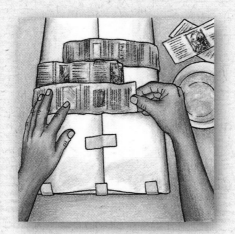

Attach additional parts of your object with glue and tape.

Apply papier-mâché paper strips and pulp to your sculpture.

Paint and finish with added materials.

Art Criticism

A

Student artworks

Describe

What did the artists show in these sculptures?

Analyze

How do you think they built the basic form? How are the forms decorated?

Interpret

What is the theme of this display of sculptures?

Evaluate

How are these artworks in the Pop Art style?

Imagination
Being Different

In the Past

In the late 1500s, Italian artist Annibale Carracci tried something different when he painted this view of a river. Unlike earlier Renaissance artists, he made the landscape the subject of his painting, rather than a background for human activities. Also, unlike other artists of his time, he allowed his brushwork to show.

A

Annibale Carracci, *River Landscape*, ca. 1590. Oil painting.

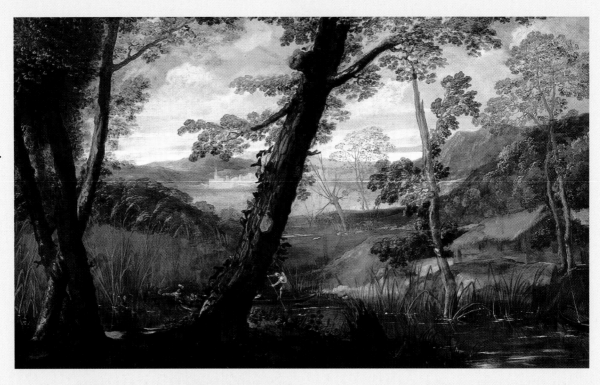

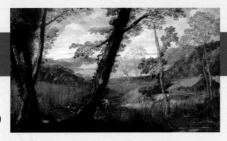

In the Past

ca. 1590

1596–1614

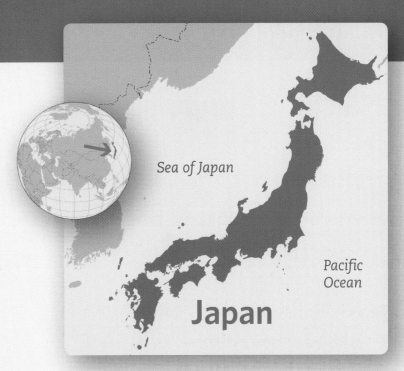

In Another Place

Artists in **Japan** in the late 1500s were also painting views of nature. These artists often painted with ink on silk. Japanese artists created pictures with realistic images of trees, birds, and animals in the foreground. Unlike paintings in Europe, the backgrounds were often entirely blank. In this style of landscape painting, the artists used negative space to suggest distance.

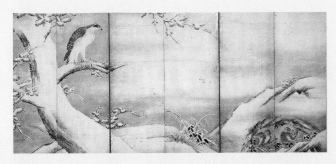

B Kano School, *Falcon on an Oak Tree Watching Monkeys*, 1596–1614. Ink and gouache.

In Daily Life

We all respond to, and are influenced by, the world around us. We can also be influenced by the artworks we see in museums and galleries. Getting inspiration from art does not mean copying the work of other artists. It's simply a starting point for developing your own ideas.

In the Present

C

a

b

c

d

Match each phrase to a picture.

1 a Pop Art sculpture

2 a nonobjective artwork

3 an abstract still life

4 a realistic still life

Write About Art

Jackie Ferrara used wood to make the sculpture in Ⓐ. Pretend you saw this artwork during a visit to a museum. Write a postcard to a friend describing this sculpture. Tell your friend what you think it resembles. Tell what it is made of and how you think the artist put it together.

Aesthetic Thinking

What needs to happen in order for an object found in a junkyard to become art? Once junk, always junk?

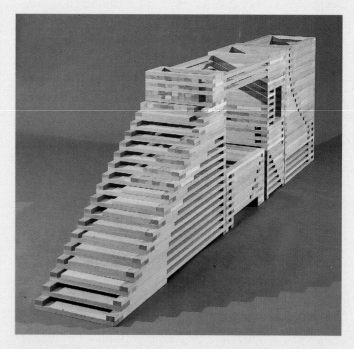

Ⓐ Jackie Ferrara, *A211 Trannik*, 1980. Wood sculpture.

Art Criticism

B Dorothea Rockburne, *Guardian Angel II*, 1982.
Watercolor painting.

Describe
What do you see in this artwork?
What words can you use to describe
the shapes?

Analyze
What do you think are the most
important elements in this artwork?
What do you notice first? Why?

Interpret
Why might this artwork be a good
illustration for a math book?

Evaluate
Do you think this is a beautiful
artwork? Why or why not?

Meet Dorothea Rockburne

Dorothea Rockburne was born in Quebec, Canada, in 1932.
Her artworks are generally made of paper. She works with
materials in nontraditional ways. When planning her paintings
and folded-paper constructions, she often follows the rules of
mathematics and geometry.

Art Safety

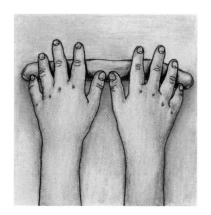

1 If you feel sick or have a health problem, tell your teacher. For example, if you have a rash or scratches on your hands, you should not use clay until your skin heals.

2 Make sure your art materials have a label that says nontoxic. Nontoxic means the materials are safe to use. Read any words that say "Caution." Find out what the words mean.

3 Some tools and materials have sharp points or edges. Use these very carefully. Make sure the sharp objects are pointing away from your body.

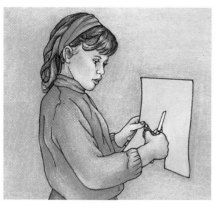

4 Use all art tools and materials with care. Keep the tools and materials away from your eyes, mouth, and face.

5 Learn to use art materials neatly. After art lessons, wash your hands to remove paint, clay, or other materials. Always wash your hands before you eat food.

6 If you drop or spill something, quietly help to clean it up. A wet floor or a floor with pieces of art materials on it can be unsafe to walk on.

You Can Help

1 Help everyone get ready for art. For some lessons, wear an apron or an old shirt. Button the shirt in the back and roll up the sleeves.

2 Help to clean up. Stack and put art materials away neatly. Wash brushes and store them with the hairs pointing up.

3 Share the art tools and materials. Save materials you can use again. You can recycle some materials to create art.

4 Save your artwork in a portfolio. Write your name and date on all of your sketches and other work. This will help you see and know what you are learning.

5 When you discuss art, listen carefully. Think about what people say. Ask thoughtful questions. In art, there is usually more than one answer to questions.

6 Learn to use art words. Use a dictionary or the glossary on pages 191–197 to find the meaning of art words. Share new words with your friends.

Horizontal

Vertical

Diagonal

Curved

Zigzag

Dotted

Dashed

Thin

Thick

Elements of Art
Shape and Form

Geometric shapes

Circle Triangle Square Rectangle

Free-form shapes

Geometric forms

Sphere Pyramid Cube Cone

Texture

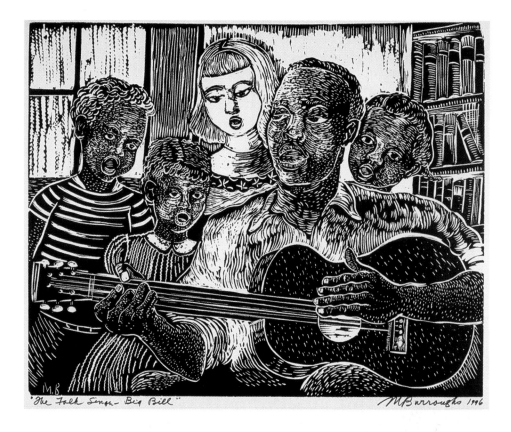

Look at the textures in this picture.

Margaret Burroughs,
The Folk Singer—Big Bill,
1996. Block print.

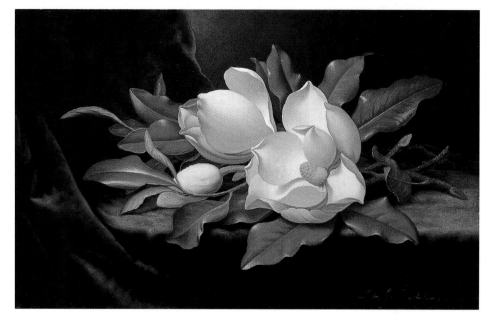

What looks smooth and silky in this picture?

Martin Johnson Heade,
*Giant Magnolias on a
Blue Velvet Cloth*,
ca. 1890. Oil painting.

Elements of Art
Color and Value

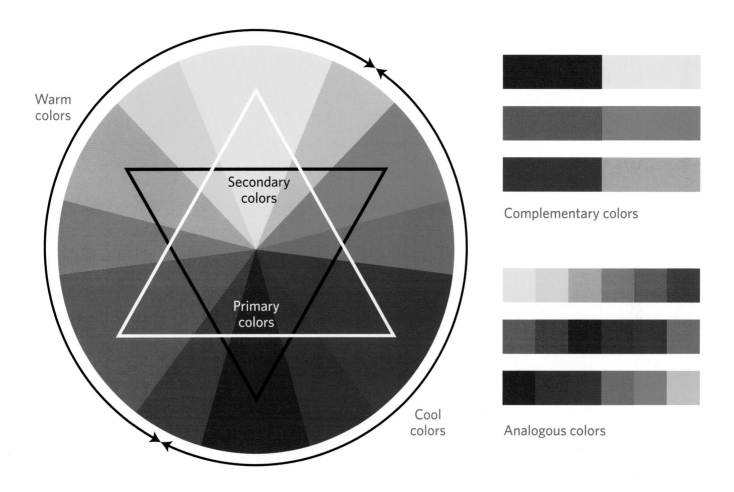

Warm colors

Secondary colors

Primary colors

Cool colors

Complementary colors

Analogous colors

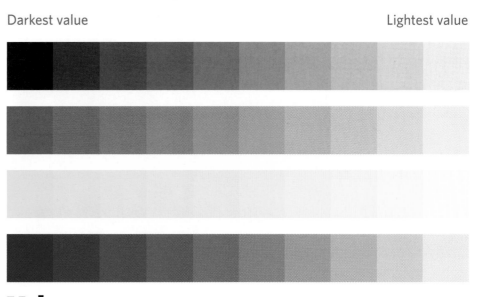

Darkest value

Lightest value

Value

Elements of Art
Shape and Space

Artists plan how they organize the shapes and spaces in a composition.

Close objects and people are near the bottom.

Far away objects and people are near the top.

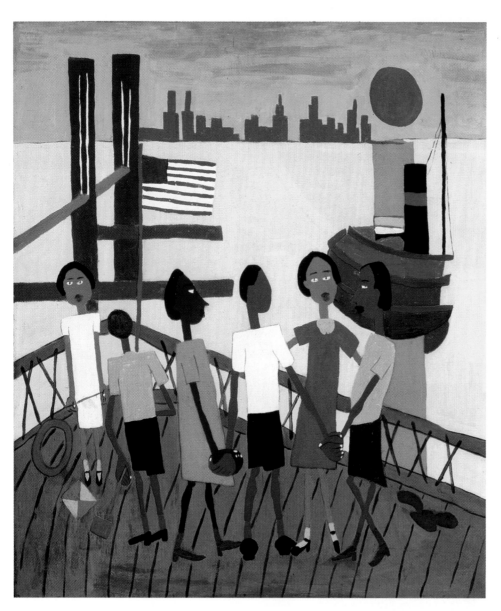

William H. Johnson, *Ferry Boat Trip*, ca. 1943–1944. Oil painting.

Positive shapes and spaces

Negative shapes and spaces

Pattern

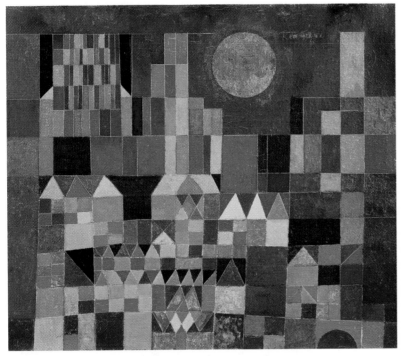

Paul Klee, *Castle and Sun*, 1928. Oil painting.

A pattern of shapes

A pattern of colors

A pattern of lines that look like textures.

Movement and Rhythm

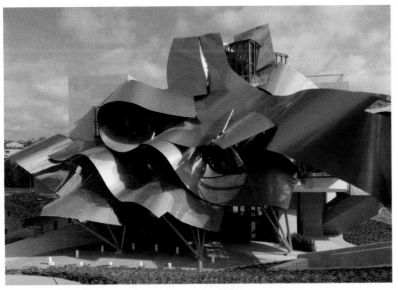

Frank Gehry, Hotel Marques de Riscal Elciego, Spain.

This building shows movement and rhythm. Look at the free-form shapes and wavy lines.

Variety and Unity

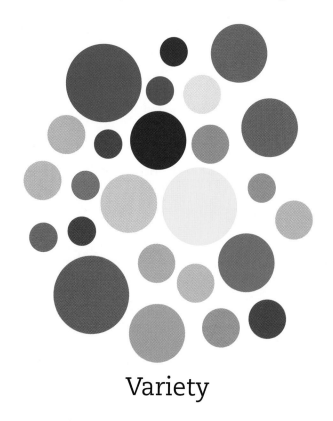

Variety

Unity

Symmetrical Balance

Proportion

Glossary

abstract
abstracto
An artwork usually based on a known subject, but the artist leaves out details, simplifies, or rearranges visual elements.

analogous colors
colores análogos
Closely related colors that have one hue in common. For example, blue, blue-violet, and violet all contain the color blue.

animation
animación
A type of motion picture created from a series of drawings photographed individually. Each drawing shows a small change in movement. When the pictures are shown quickly, one after the other, the illusion of motion is created.

animator
animador
An artist who creates drawings for an animated cartoon.

architect
arquitecto
An artist who designs and plans the construction of buildings.

armature
armazón
A framework used to to support other material.

assemblage
ensamblaje
An artwork created with a variety of materials and found objects.

asymmetrical balance
equilibrio asimétrico
The appearance that artwork is equal or balanced on two sides, without being identical.

background
fondo
The part of an artwork that appears to be in the distance or behind other objects.

batik
batik
A method of dyeing cloth using wax to protect certain areas of the cloth from the dye.

brayer
rodillo de goma para entintar
A small rubber roller used to spread ink evenly on a surface before printing.

caricature
caricatura
A picture in which a person or animal's distinctive features, such as nose, ears, or mouth, are changed for a comical appearance.

center of interest
punto de interés
The main, or first thing, you notice in an artwork.

cityscape
paisaje urbano
An artwork that uses elements of the city (building, streets, shops) as subject matter.

coil method
método espiral
Pottery made by joining rope-like pieces of clay. Used to make pots, bowls, and sculptures.

collagraph

colográfico

A print made from a surface that has been constructed in the manner of a collage.

color scheme

combinación de colores

A plan for selecting and organizing colors for an artwork.

complementary colors

colores complementarios

Those that are directly opposite each other on the color wheel, such as red and green, blue and orange, and violet and yellow. When complements are mixed together, they form a neutral brown or gray. When they are used side by side in a work of art, they create strong contrasts.

contour drawing

dibujo contorno

Shows the edges or outline of a shape or form.

cool colors

colores frescos

Varieties of blue, green, and violet that remind people of cool things.

distortion

distorsión

To change the way something looks by changing some of its features.

dye

tintura

A colored liquid that sinks into a material and stains it.

emphasis

énfasis

An important part of an artwork attracting the viewer's attention.

exaggeration

exageración

When an artist enlarges the size of some parts of an artwork in order to draw attention to that part.

exterior

exterior

The outside surface of an object; for example, the outside walls of a building.

fabric

tela

Cloth used to create artworks.

firing

encender

In ceramics, the process of exposing a clay object to high heat, usually in a furnace-like oven called a kiln, in order to harden it permanently.

floor plan

plano de planta

A drawing that shows a room's size and the location of windows and doors. It is often viewed from above.

foreground

primer plano

In a scene or artwork, the part that seems near or close to you.

forms

formas

An element of design that is three-dimensional, such as a cube, sphere, or cylinder. A form has height, width, and thickness, and it is not flat.

geometric
geométrico
Circles, squares, rectangles, and triangles are all examples of geometric shapes, as are cones, cubes, cylinders, slabs, pyramids, and spheres.

gesture drawing
dibujo gestual
A drawing done quickly to capture movement or a pose of a person or object.

guidelines
guías
A line used to guide or aid in drawing an object.

history painting
pintura histórica
Shows something that happened in the past.

hue
tono
The common names for colors, such as red, yellow, blue, orange, green, and violet.

human-made environment
ambiente artificial
The buildings and structures in the world that are created by humans.

illusion
ilusión
Artwork that is flat, but gives the appearance of being three-dimensional.

imagination
imaginación
Creating a mental picture of something that is unlike things one has seen.

interior designer
diseñador de interiores
A person who plans the colors, patterns, and textures of spaces inside a building. They often choose furniture and its placement.

intermediate colors
colores intermedios
Those made from a primary and a secondary color: red-orange, yellow-orange, blue-violet, and so forth.

inventive
inventivo
When you have ideas no one else has thought about.

kente cloth
tela de kente
Strips of fabric woven together by the Ashanti people of Ghana, Africa.

kiln
horno
A special oven or furnace that can be heated to a high temperature to fire objects made of clay.

landmark
monumento histórico
A place in a neighborhood or town that almost every person knows about.

landscape
paisaje
An artwork that shows natural scenery such as mountains, valleys, trees, rivers, and lakes.

landscape architect
arquitecto de paisajes
A person who plans parks, gardens, and other outdoor spaces.

lettering
leyenda
The use of letters on common objects. Frequently used on posters, billboards, and cereal boxes.

line quality
calidad de la línea
The way a line looks.

loom
telar
A frame or support used to weave cloth. Some threads are held by the loom while other threads are woven through them.

maquette
maqueta
Scale model of a larger sculpture.

masks
máscaras
A type of sculpture that covers the face.

materials
materiales
The parts from which an artwork is made.

memorial
monumento conmemorativo
A building that has a special purpose. Many memorials are built to honor the memory of a person.

middle ground
término medio
Parts of an artwork that appear to be between objects in the foreground and objects in the background.

model
modelo
A person who poses for an artist.

mola
mola
Brightly colored panels of cloth often featuring creatures, plants, and abstract designs.

monoprint
monograbado
A printing process that usually results in one print rather than many.

mosaic
mosaico
Artwork made by fitting together tiny pieces of colored glass, tiles, stones, paper, or other materials.

natural environment
ambiente natural
All the rivers, hills, trees, and other elements of the earth.

nonobjective
sin objecto
An artwork where none of the objects can be recognized. The viewer sees only lines, shapes, and other design elements.

organic
orgánico
A shape in the natural environment. Often they are uneven or curvy lines and shapes that show rivers, hills, and other elements in the world around you.

overlap
superposición
When one shape covers up some or all other parts in an artwork.

paper cutting
recorte de papel
Artwork created by cutting designs and pictures out of paper with scissors.

paper pulp
pasta de papel
Soaked paper and water that are combined in a blender.

papier-mâché
papel-maché
A paper pulp used for modeling and made by mixing small bits of paper with water and then glue.

pattern
patrón
Designs that have repeated elements, such as lines, shapes, or colors.

photography
fotografía
The creation of a picture or portrait using a camera.

Pop Art
arte popular
Artwork that shows objects from everyday life. Examples are food, tools, and items seen in stores and advertisements.

portrait
retrato
An artwork that shows the likeness of a real person.

pose
posar
A special way to stand or sit for an artist.

pottery
cerámica
A container created by hand from ceramic clay.

primary colors
colores primarios
Those from which other colors can be made: red, yellow, and blue.

print
grabado
A copy of an image, usually made by pressing an inked surface or object onto paper. Also the process of copying an image in this manner.

profile
perfil
A view of something from the side.

proportion
proporción
Shows how parts are related to each other in size and amount.

quilt
edredón
Fabric artwork made by stitching together two layers of cloth with a layer of padding in between.

quilt block
bloque de edredón
A quilt block is a square-shaped pattern repeated and combined to form a quilt top.

radial balance
equilibrio radial
When an art design spreads out from a center point.

real texture
textura real
A surface that you can feel. Textures can feel rough, smooth, gritty, or fluffy.

recycled paper
papel reciclado
Artwork created by reusing paper.

resist painting
cuadro de resistencia
A process that blocks out certain areas of a surface that an artist does not want to be affected by dye, paint, or another substance.

sculpture
escultura de alambre
A three-dimensional artwork made by carving, modeling, or joining materials.

seascape
paisaje marítimo
Artwork that shows scenes of the ocean or sea.

secondary colors
colores secundarios
Those that can be mixed from primary colors: orange, green, and violet.

shades
sombras
Colors mixed by adding black. A dark value of a hue, such as dark blue.

shading
sombrado
A gradual change from light to dark that gives an artwork a realistic, three-dimensional quality.

shadow puppet
títere a contraluz
A type of puppet that is moved behind a lighted screen so that only the puppet's shadow can be seen.

sketch
bosquejo
A drawing without a lot of detail.

still life
naturaleza muerta
An artwork that shows nonliving things, such as books, candles, fruit, and flowers.

stitchery
pespunteado
A general term for artwork created with needles, thread or yarn, and cloth. A stitch is one in-and-out movement of a threaded needle.

structure
estructura
Something that is built, such as a building or bridge.

symmetrical balance
equilibrio simétrico
When both sides of a design are exactly or nearly the same.

tesserae
tesserae
Small pieces of glass, tile, stone, paper, or other materials used to make a mosaic.

three dimensional
tridimensional
Artwork that can be measured three ways: height, width, depth o r thickness. Artwork that is not flat.

tints
tintes
A color mixed by adding white. A light value of a color. For example, pink is a tint of red.

unity
unidad
When the lines, shapes, and colors in an artwork are working together, like a team.

value
valor
The lightness or darkness of a color. Pink is a light value of red.

vessel
recipiente
A container.

view
vista
The position of something when you look at it. It can be from above, below, or straight ahead.

visual symbol
símbolo visual
Lines, colors, and shapes that stand for something else, as a red heart may stand for love.

visual texture
textura visual
How a surface appears to feel when you look at it.

warm colors
colores cálidos
Those that remind people of warm things. Varieties of red, yellow, and orange.

wire scultpure
escultura de alambre
A three-dimensional scupture created in wire that captures motion.

zoetrope
zootropo
A simple drawing that appears to be moving.

Credits

Title page: Georges Seurat, *A Sunday on La Grande Jatte–1884*, 1884–86. Oil on canvas, 81 3/4" x 121 1/4" (207.5 x 308.1 cm). The Art Institute of Chicago. ii: iStockphoto.com/Steve Geer. Utagawa Hiroshige, *Asakusa Ricefields and Torinomachi Festival*, No. 101 from *One Hundred Famous Views of Edo*, 1857. Woodblock print, 13 3/8" x 8 ¾" (13 x 9 cm). Brooklyn Museum. iii: M. C. Escher, *Drawing Hands*, 1948. Lithograph, 11" x 13" (28.2 x 33.2 cm). The M. C. Escher Company B.V. iv: Frida Kahlo, *Portrait of Virginia*, 1929. Oil on masonite, 30" x 23.4" (76.5 x 59.5 cm). ©Banco de Mexico Trust. Photo credit: Schalkwijk/Art Resource, NY. Frank Memkus, *Whirlygig* entitled *America*, ca. 1938–42. Painted wood and metal, 80 3/4" x 29" x 40" (205.1 x 73.7 x 101.6 cm). The Art Institute of Chicago. v: Postnik Yakovlev, St. Basil's Cathedral, 1555–61. Red Square, Moscow. vi: iStockphoto.com/Bill Raboin. Betsy Begor pottery. Courtesy of Betsy Begor. vii: Bette Nassar Clark, *Houses*, 1840–1860. Pieced cotton, 92" x 96" (233.7 x 243.8 cm). The Newark Museum. Art Resource, NY. Puppet from a Thai Buddhist drama. Private collection, The Hague, The Netherlands. Photo credit: Werner Forman/Art Resource, NY. viii: iStockphoto.com/AVTG. Elizabeth Murray, *Wiggle Manhattan*, 1992. Color lithograph on paper, 57 7/8" x 28 3/4" (147 x 73 cm). The Museum of Modern Art, New York, NY. ©The Museum of Modern Art/Licensed by SCALA/Art Resource, NY. ©Elizabeth Murray, courtesy PaceWildenstein, New York. ix: Wanda Gag, *Stone Crusher*, 1929. Lithograph, 14 3/8 x 11 3/8" (37 x 29 cm). Philadelphia Museum of Art. Grant Wood, *Landscape*, 1930. Oil on paperboard, 12 5/8" x 14 5/8" in. (32.1 x 37.2 cm). Smithsonian American Art Museum, Washington, DC. Photo credit: Smithsonian American Art Museum, Washington, DC/Art Resource, NY. © VAGA, NY. x: Heinrich Campendonk, *Landscape*, 1917. Oil on canvas, 26 3/8" x 19 1/2" (67 x 49.5 cm). The Art Institute of Chicago. Heinrich Campendonk Art ©2007 ARS, NY/VG Bild-Kunst, Bonn. Berthe Morisot, *Girl in a Boat with Geese*, ca. 1889. Oil on canvas, 25 3/4" x 21 1/2" (65.4 x 54.6 cm). Ailsa Mellon Bruce Collection. ©2007 Board of Trustees, National Gallery of Art, Washington, DC. Susan J. Geissler, *Puddle Jumper*, 2005. Sculpture. Courtesy of the artist. Charles Bullfinch, *Church of Christ*, 1816. Lancaster, MA. Photo credit: Steve Dunwell. xi: *Young Mardi Gras Indian*, New Orleans, Louisiana, U.S.A., 1989. Sydney Byrd. *Two Inca ponchos with geometric designs, worn by people of high status*, ca. 1380–1520. South America, South Coast, Peru, Inca Culture. Ethnologisches Museum, Staatliche Museen zu Berlin, Berlin. Werner Forman/Art Resource, NY. Toshiyuki Kita, *Wink Lounge Chair* (model 111.01), 1980. Polyurethane foam, steel, and Dacron, Overall (upright): 40 5/8" x 33" x 31 5/8" (103.2 x 83.8 x 80.3 cm) seat h. 14 3/4" (37.5 cm); (reclining): 24 3/8" x 33" x 75 3/4" (61.9 x 83.8 x 192.4 cm). Manufactured by Cassina, S.p.A., Milan. Atelier International Ltd. (SC21.1981.a-g) The Museum of Modern Art, New York, NY, U.S.A. Photo credit : Digital Image © The Museum of Modern Art/Licensed by SCALA/Art Resource, NY. xii: Faith Ringgold, *Tar Beach 2*, 1990. Silk quilt, 68" x 64" (172.72 x 162.56 cm). Faith Ringgold ©1990. Mary Cassatt, *The Child's Bath*, 1893. Oil on canvas, 39 1/2" x 26" (100.3 x 66.1 cm). The Art Institute of Chicago. Mogolion (Casas Grandes style), Macaw Bowl, Tardio Period, 1300–1350. Earthenware with polychrome slip painting, 5 1/4" x 8" x 6 1/4" (13.3 x 20.3 x 15.9 cm). Museum of Fine Arts, Houston (Miss Ima Hogg). xiii: Frida Kahlo, *Portrait of Virginia*, 1929. Oil on masonite, 30" x 23 1/2" (76.5 x 59.5 cm). Copyright Banco de Mexico Trust. Photo Credit: Schalkwijk / Art Resource, NY. Doris Lee, *Thanksgiving*, ca. 1935. Oil on canvas, 28 1/8" x 40 1/8" (71.3 x 101.8 cm). The Art Institute of Chicago. xiv: Diego Rivera, *Children at Lunch*, 1935. Private collection, ©Banco de Mexico Trust.

Private collection. Art Resource, NY. Sofonisba Anguissola, *A Game of Chess, Involving the Painter's Three Sisters and a Servant*, 1555. Oil on canvas, 28 1/4" x 38 1/4" (72 x 97 cm). Muzeum Narodow, Poznan, Poland. Photo Erich Lessing/Art Resource, NY. India, The Taj Mahal at Agra, Uttar Pradesh, built by Shah Jahan in 1632-43, with European sightseers on the terrace. Watercolor painting with angels pouring gold from the clouds. Persian text and floral decoration in the border. British Library, London. Photo: Erich Lessing/Art Resource, NY. xv: Ancient Egypt, *The Watering of Plants in a Garden*, 19th Dynasty, 1300–1200 BCE. Painting from the tomb of the sculptor Ipui (no. 217), in Deir el-Medina (Thebes-West). Photo: Bildarchiv Preussischer Kulturbesitz/Art Resource, NY. Arthur Lismer, *A September Gale, Georgian Bay*, 1920. Oil on canvas, 20 1/4" x 24" (51.5 x 61 cm). National Gallery of Canada, Ottawa. China, wall hanging. Private collection. Francisco José de Goya y Lucientes, *Portrait of General José Manuel Romero*, 1810. Oil on canvas, 41 1/2" x 34 1/2" (105.41 x 87.63 cm). The Art Institute of Chicago.) Leonardo da Vinci, *Mona Lisa (La Gioconda)*, 1503–06. Oil on wood, 30 1/4" x 20 7/8" (77 x 53 cm). Photo: R. G. Ojeda. Louvre, Paris, Reunion des Musées Nationaux/Art Resource, NY. Tom Wesselmann, *Still Life #30*, © Estate of Tom Wesselmann/Licensed by VAGA, New York, NY, 1963. Assemblage: Oil, enamel, and synthetic polymer paint on composition board with collage of printed advertisements, plastic flowers, refrigerator door, plastic replicas of 7-Up bottles, glazed and framed color reproduction, and stamped metal, 48 1/2" x 66" x 4" (122 x 167.5 x 10 cm). Philip Johnson. Museum of Modern Art, New York, NY. ©The Museum of Modern Art/Licensed by SCALA/Art Resource, NY. David Hockney, *Garrowby Hill*, 1998. Oil on canvas, 60" x 76" (152.4 x 193 cm). Museum of Fine Arts, Boston. xvii: Heinrich Campendonk, *Landscape*, 1917. Oil on canvas, 26 3/8" x 19 1/2" (67 x 49.5 cm). The Art Institute of Chicago. Heinrich Campendonk Art ©2007 ARS, NY/VG Bild-Kunst, Bonn. *Reclining Jaguar*, 1440–1521. Aztec. Stone, 5" x 11" 5 3/4" (12.7 x 27.9 x 14.6 cm.) Brooklyn Museum. Vincent van Gogh, *The Bedroom*, 1889. Oil on canvas, 29" x 36 1/4" (73.6 x 92.3 cm). The Art Institute of Chicago. xviii: Vincent van Gogh, *The Starry Night*, 1889. Oil on canvas, 29" x 36 1/4" (73.7 x 92.1 cm). The Museum of Modern Art, New York. ©The Museum of Modern Art/Licensed by SCALA / Art Resource, NY. xix: Paul Klee, *Castle and Sun*, 1928. Oil on canvas. Private collection, Great Britain. Erich Lessing/Art Resource, NY. Paul Klee Art ©2007 ARS, NY/VG Bild-Kunst, Bonn. Frank Gehry, Hotel Marques de Riscal Elcigo, (Alava) Spain. Photo: www.thomasmayerarchive.com, 2006. xx: Loïs Mailou Jones, *Coin de la Rue Medard*, 1947. Oil on canvas, 18" x 22" (45.7 x 56 cm). The Phillips Collection, Washington, DC.

Unit 1

2: (B) Janet Fish, *Green Tea Cup*, 1999. Oil on canvas, 50" x 40" (127 x 101.6 cm). The Seavest Collection of Contemporary American Realism. 3: (A) Janet Fish, *Dog Days*, 1993. Oil on canvas, 46" x 80" (116.8 x 203.2 cm). The Seavest Collection of Contemporary American Realism. Photo of Janet Fish ©www.StewartStewart.com 1996. 4: (A) Jean Auguste Dominique Ingres, *Sheet of Studies with the Head of the Fornarina and Hands of Madame de Senonnes*, 1814–16. Graphite, with stumping, on light-weight yellowish-tan wove paper, laid down on white wove paper, perimeter mounted on cream wove paper, 7.4" x 8 1/4" (18.9 x 21 cm). The Art Institute of Chicago. (B) M. C. Escher, *Drawing Hands*, 1948. Lithograph, 11" x 13" (28.2 x 33.2 cm). The M. C. Escher Company B.V. 5: (C) Patricia A. Renick, sketches for *Spectrum I*, 1991. Courtesy of the artist. (D) Patricia A. Renick, *Spectrum I*, 1991. 38" x 46" (96 x 117 cm). Courtesy of the artist. 6: (A) Edgar Degas, *Four Studies of a Dancer*, 1878–79. The Louvre, Paris. Photo: J. G. Berizzi;

Photo credit: Réunion des Musées Nationaux/Art Resource, NY. (B) Edgar Degas, *Little Dancer, Aged Fourteen*, executed in wax 1878–81; cast in bronze after 1922. Bronze, silk, and tulle, 39" (99 cm) tall. The Philadelphia Museum of Art. 8: (B) iStockphoto.com/Josef Volavka. 9: (A) Dwight Billedeaux, *Inter-Tribal Internet*. Phone and computer wire, 6" x 14" x 5" (15.2 x 35.6 x 12.7 cm). Courtesy of the artist and Sacajawea Gallery, Montana. (C) iStockphoto.com/Jyeshern Cheng. (D) iStockphoto.com/IanMarchant. 12: (A) Beatriz Milhazes, *Succulent Eggplants*, 1996. Synthetic polymer paint on canvas, 75" x 96" (190 x 245 cm). Museum of Modern Art, New York, NY. ©The Museum of Modern Art/Licensed by SCALA/Art Resource, NY. (B) Richard Diebenkorn, *Girl with Plant*, 1960. Oil on canvas, 80" x 69 1/2" (203 x 176 cm). The Phillips Collection, Washington, DC. 14: (A) Henri Edmond Cross, *Coast Near Antibes*, 1891–92. Oil on canvas, 25 5/8" x 36 1/4" (65 x 92 cm). John Hay Whitney Collection, Image ©2007 Board of Trustees, National Gallery of Art, Washington. 15: (B) Winslow Homer, *Sunshine and Shadow, Prout's Neck*, 1894. Watercolor over graphite on ivory wove paper, 15" x 21.5" (38.5 x 54.6 cm). Mr. and Mrs. Martin A. Ryerson Collection, The Art Institute of Chicago. 16: (B) iStockphoto.com/Steve Geer. 17: (A) George Copeland Ault, *From Brooklyn Heights*, 1925, Oil on canvas, 30" x 20" (76.2 x 50.8 cm). The Newark Museum, Newark, NJ/Art Resource, NY. (C) iStockphoto.com/Oleg Chirkashenko. (D) iStockphoto.com/S. Greg Panosian. 20: (A) Grant Wood, *Landscape*, 1930. Oil on paperboard, 12 5/8" x 14 5/8" in. (32.1 x 37.2 cm). Smithsonian American Art Museum, Washington, DC. Photo credit: Smithsonian American Art Museum, Washington, DC/Art Resource, NY. © VAGA, NY. 21: (B) Charles Sheeler, *Incantation*, before 1949. Oil on canvas, 32.6" x 28.7" (83 x 73 cm). Brooklyn Museum of Art. 23: (C) Thomas Worthington Whittredge, *Study of a Tree, Colorado*, 1871. Graphite pencil on paper, 15" x 11 5/8" (38.1 x 29.5 cm). Museum of Fine Arts, Boston. 24: (B) iStockphoto.com/Monika Lewandowska. 25: (A) Andrew Wyeth, *Soaring*, 1942–50. Tempera on masonite, 48" x 87" (122 x 121 cm). Shelburne Museum, Shelburne, Vermont. (C) iStockphoto.com/Christoph Ermel. (D) Michael Dunning/Getty Images. 28: (A) Egyptian, *A garden pool; fragment of a wall painting from the tomb of Nebamun*, 18th dynasty, around 1350 BCE. British Museum. Photo credit: Erich Lessing/Art Resource, NY. 29: (B) Rafael Ferrer, *El Sol Asombra*, 1989. Oil on canvas, 60" x 72" (152.4 x 182.8 cm). Butler Institute of American Art. (C) Betsy Graves Reyneau, *Portrait of George Washington Carver*, 1942. Oil on canvas, 44 1/4" x 35" (112.4 x 88.9 cm). National Portrait Gallery, Smithsonian Institution, Washington, DC/Art Resource, NY. 30: (a) George Copeland Ault, *From Brooklyn Heights*, 1925, Oil on canvas, 30" x 20" (76.2 x 50.8 cm). The Newark Museum, Newark, NJ/Art Resource, NY. (b) Henri Edmond Cross, *Coast Near Antibes*, 1891–92. Oil on canvas, 25 5/8" x 36 1/4" (65 x 92 cm). John Hay Whitney Collection, Image ©2007 Board of Trustees, National Gallery of Art, Washington. (c) Andrew Wyeth, *Soaring*, 1942–50. Tempera on masonite, 48" x 87" (122 x 121 cm). Shelburne Museum, Shelburne, Vermont. (d) Edgar Degas, *Little Dancer, Aged Fourteen*, executed in wax 1878–81; cast in bronze after 1922. Bronze, silk, and tulle, 39" (99 cm) tall. The Philadelphia Museum of Art. (e) Ando Hiroshige, *Asakusa Ricefields and Torinomachi Festival*, No. 101 from *One Hundred Famous Views of Edo*, 1857. Woodblock print, 13 3/8" x 8 3/4" (13 x 9 cm). Brooklyn Museum. 31: (B) Ando Hiroshige, *Fukagawa Susaki and Jumantsubo*, No. 107, from *One Hundred Famous Views of Edo*, 1857. Color woodcut on paper, 14.2" x 9.4" (36 x 24 cm). Brooklyn Museum of Art (gift of Anna Ferris). Photo of Ando Hiroshige ©Peter Harholdt/CORBIS.

Unit 2

32: (A) Georges Seurat, *A Sunday on La Grande Jatte–1884*, 1884–86. Oil on canvas, 81 3/4" x 121 1/4" (207.5 x 308.1 cm).

The Art Institute of Chicago. 33: (B) Georges Seurat, *Port-en-Bessin*, 1888. Oil on canvas, 26" x 32 3/4" (66 x 83.2 cm). The Minneapolis Institute of Arts, The William Hood Dunwoody Fund. Photo of Georges Seurat Réunion des Musées Nationaux/Art Resource, NY. 34: (A) Frida Kahlo, *Portrait of Virginia*, 1929. Oil on masonite, 30" x 23.4" (76.5 x 59.5 cm). ©Banco de Mexico Trust. Photo credit: Schalkwijk/Art Resource, NY. (B) Solomon Getachew, *That's My Boy*, 1962. 36: (A) John Trumbull, *Declaration of Independence*, 1817. Oil on canvas, 12' x 18' (3.66 x 5.5 m). Rotunda of the United States Capitol Building. Architect of the Capitol. 37: (B) Jennie A. Brownscombe, *The First Thanksgiving at Plymouth*, 1914. Oil on canvas. Pilgrim Hall Museum. 38: (B) iStockphoto.com/Lawrence Sawyer. 39: (A) Helen Cordero, *Storyteller and Children*, 1980. Ceramic, 5 3/8" x 10 1/8" (13.6 x 25.7 cm). Fred Jones Jr. Museum of Art, University of Oklahoma. (C) Getty Images. (D) iStockphoto.com/Eileen Hart. 42: (A) Robert Indiana, *Love Crosses*, 1968. Serigraph on paper, 22.5" x 28.5" (57.1 x 72.3 cm). The Butler Institute of American Art, Youngstown, Ohio. Robert Indiana Art ©2007 ARS, NY. (B) Stephen Buggy, *Art Tool Alphabet*, 2005. Courtesy of the Artist. 43: (C) Oskar Kokoschka, Poster for a 1908 Art Exhibition. ©ARS, NY. Art Resource, NY. 44: (A) Frank Memkus, *Whirlygig entitled America*, ca. 1938–42. Painted wood and metal, 80 3/4" x 29" x 40" (205.1 x 73.7 x 101.6 cm). The Art Institute of Chicago. (B) Folk art mailboxes, National Postal Museum, Smithsonian Institution. 46: (B) Getty Images. 47: (A) Anne Coe, *Eating Crow*, 2006. Acrylic on canvas, 40" x 50" (101 x 127 cm). Courtesy of the Artist. (C) ©2007 Jupiter Images Corporation. (D) designpics.com. 50: (A) Peter Traugott, *Corner Table*. Graphite on paper, 18" x 24" (45.72 x 60.96 cm). Courtesy of the Artist. (B) Francisco José de Goya y Lucientes, *Los Caprichos #39; And So Was His Grandfather*, 1797–98. Etching and aquatint, 6 1/16" x 8 9/16" (15.4 x 21.8 cm). Museum of Fine Arts, Boston. 52: (A) Jim McNeill, *Jumper*, 2006 Digital illustration. (B) Eadweard Muybridge, *Muybridge's Horse*, 1881. Series of shots used in the newly invented zoopraxiscope. National Archives, London. Photo Credit: HIP/Art Resource, NY. 53: (B) Eadweard Muybridge, *Muybridge's Dogs*, 1881. Twelve shots of a running dog. National Archives, London. Photo Credit: HIP/Art Resource, NY. 54: (B) Animated movie, *Toy Story*, 1995. ©Buena Vista Pictures/Courtesy Everett Collection. 55: (A) Zoetrope, German, early 1900s. Paper and wood, 11" x 8" (28 x 20 cm). The Bill Douglas Centre for the History of Cinema and Popular Culture, University of Exeter. (C) Animated movie, *Toy Story*, 1995. ©Buena Vista Pictures/Courtesy Everett Collection. (D) Animated movie, *Toy Story*, 1995. ©Buena Vista Pictures/Courtesy Everett Collection. 58: (A) Apollodorus of Damascus, *Column of Trajan, Trajan Addressing His Troops*, 106–113. Marble, Rome, Italy. Davis Art Images. 59: (B) *Multi-Generation Ancestor Portrait*, Chinese, Qing Dynasty, mid to late 19th century. Ink and color on cotton cloth. ©Peabody Essex Museum 2007. (C) Jack Hollingsworth/Getty Images. 60: (a) John Trumbull, *Declaration of Independence*, 1817. Oil on canvas, 12' x 18' (3.66 x 5.5 m). Rotunda of the United States Capitol Building. Architect of the Capitol. (b) Helen Cordero, *Storyteller and Children*, 1980. Ceramic, 5 3/8" x 10 1/8" (13.6 x 25.7 cm). Fred Jones Jr. Museum of Art, University of Oklahoma. (c) Frida Kahlo, *Portrait of Virginia*, 1929. Oil on masonite, 30" x 23.4" (76.5 x 59.5 cm). ©Banco de Mexico Trust. Photo credit: Schalkwijk/Art Resource, NY. (d) Zoetrope, German, early 1900s. Paper and wood, 11" x 8" (28 x 20 cm). The Bill Douglas Centre for the History of Cinema and Popular Culture, University of Exeter. (A) Kathe Kollwitz, *Self-Portrait Drawing*, 1933. Charcoal on brown laid Ingres paper, 18 3/4" x 25" (47.7 x 63.5 cm). ©2007 Board of Trustees, National Gallery of Art, Washington, DC. 61: (B) Alice Neel, *Benny and Mary Ellen Andrews*, 1972. Oil on canvas, 60" x 50" (152.2 x 127 cm). The Museum of Modern Art, New York, NY. ©The Museum of Modern Art/Licensed by SCALA/Art Resource, NY. Photo of Alice Neel ©Oscar White/CORBIS.

Unit 3

62: (A) Charles Sheeler, *The Artist Looks at Nature*, 1943. Oil on canvas, 21" x 18" (53.3 x 45.7cm). The Art Institute of Chicago (Gift of the Society for Contemporary American Art). 63: (B) Charles Sheeler, *Bucks County Barn*, 1932. Oil on composition board, 24" x 30" (61 x 76 cm). Museum of Modern Art, New York, NY. ©The Museum of Modern Art/Licensed by SCALA/Art Resource, NY. Photo of Charles Sheeler ©Time & Life Pictures/Getty Images. 64: (A) ©David Frazier/CORBIS. (B) Grant Wood, *Haying*, 1939. Oil on paperboard-mounted canvas on hardboard, 13" x 14 3/4" (32.8 x 37.7 cm). ©2007 Board of Trustees, National Gallery of Art, Washington. 65: (C) Marsden Hartley, *New Mexico Landscape*, 1919. Oil on canvas, 30" x 36" (76.2 x 91.4 cm). Philadelphia Museum of Art, The Alfred Stieglitz Collection. 66: (A) Vincent van Gogh, *View of Arles*, 1888. Pencil, India ink with reed pen, and wash on white paper, 17 1/16" x 21 5/8" (43.3 x 55 cm). The RISD Museum, Rhode Island School of Design. 67: (C) Claude Monet, *Japanese Footbridge and the Water Lily Pond, Giverny*, 1899. Oil on canvas, 35 1/8" x 36 3/4" (89.2 x 93.3 cm). Philadelphia Museum of Art: The Mr. and Mrs. Carroll S. Tyson, Jr., Collection. 68: (B) iStockphoto.com/Randy Mayes. 69: (A) Mirei Shigemori, *Tofuku-ji Hondo*, 1939. South garden, sand and moss hills, general view. Kyoto, Japan. Davis Art Images. (C) iStockphoto.com/Olga Lyubkina. (D) iStockphoto.com/Jason van der Valk. 72: (A) A view of the northern side of downtown Pittsburgh. iStockPhoto.com/SAR Enterprises. 74: (A) John Francis Bentley, *Westminster Roman Catholic Cathedral*, 1895–1903. West façade, south end, showing fenestration and stonework. Davis Art Images. (B) Eero Saarinen, *United States Embassy*, 1960. Façade close-up of corner. Gernrode, Germany. Davis Art Images. 75: (C) Medieval, *Lasarevskaya Church*, ca. 1350–1399. Rear view. Kizhi, Russia. Davis Art Images. 76: (B) iStockphoto.com/Pavel Losevsky. 77: (A) Frank Lloyd Wright, *Arthur Davenport House*, 1901. Interior: living room. River Forest, Illinois. ©Thomas Heinz Photography. ©2007 The Frank Lloyd Wright Foundation/ARS, NY. (C) Phillip Spears/Getty Images. (D) iStockphoto.com/Pavel Losevsky. 80: (A) Early Christian, *Mausoleum of Galla Placidia, interior: Good Shepherd mosaic*, 425–450. Ravenna, Italy. Davis Art Images. 81: (B) *Mosaic of a Menorah with Lulav and Ethrog*, from Hammam Lif, Tunisia, sixth century. Brooklyn Museum of Art. (C) Early Christian, *Chapel detail: mosaic floor*, fifth century. Masada, Israel. Davis Art Images. 82: (A) Ustad Ahmad Ma'mar Lahori, *Taj Mahal*, 1632–54. Agra, India. Davis Art Images. 83: (B) Rokuon-ji, Kinkaku (Golden Pavilion), 1394–1427, rebuilt 1955. Kyoto, Japan. Davis Art Images. (C) Postnik Yakovlev, *St. Basil's Cathedral*, 1555–61. Red Square, Moscow. 84: (B) ©2007 Dennis MacDonald and World of Stock. 85: (A) André Derain, *Charing Cross Bridge*, 1906. Oil on canvas, 31.5" x 39.5" (80.3 x 100.3 cm). ©2007 Board of Trustees, National Gallery of Art, Washington. André Derain Art ©2007 ARS, NY/ADAGP, Paris. (C) iStockphoto.com/Three Jays. (D) iStockphoto.com/Klaas Lingbeek-van Kranen. 88: (A) Anasazi, *Cliff Palace*, twelfth–thirteenth centuries. Mesa Verde, Colorado. Davis Art Images. 89: (B) Moshe Safdie, *Habitat 67*, 1964–66. Montreal, Canada. Davis Art Images. (C) iStockphoto.com/Steven Gibson 90: (a) Frank Lloyd Wright, *Arthur Davenport House*, 1901. Interior: living room. River Forest, Illinois. ©Thomas Heinz Photography. ©2007 The Frank Lloyd Wright Foundation/ARS, NY. (b) André Derain, *Charing Cross Bridge*, 1906. Oil on canvas, 31.5" x 39.5" (80.3 x 100.3 cm). ©2007 Board of Trustees, National Gallery of Art, Washington. André Derain Art ©2007 ARS, NY/ADAGP, Paris. André Derain Art ©2007 ARS, NY/ADAGP, Paris. (c) Mirei Shigemori, *Tofuku-ji Hondo*, 1939. South garden, sand and moss hills, general view. Kyoto, Japan. Davis Art Images. (d) Medieval, *Lasarevskaya Church*, ca. 1350–1399. Rear view. Kizhi, Russia. Davis Art Images. (A) Pierre Bonnard, *The Window*, 1925. Oil on canvas, 50 1/2" x 43" (128.27 x 109.22 cm). Tate Gallery, London/Art Resource, NY. 91: (B) Berenice Abbott, *Walkway, Manhattan Bridge*, 1935. Gelatin silver print, matte, double weight paper. The New York Public Library. Photo of Berenice Abbott ©Arnold Newman/Getty Images.

Unit 4

92: (A) Rosa Bonheur, *Wild Boars in the Snow*, 1872–77. Oil on wood panel, 8 1/4" x 12" (21 x 30.8 cm). Cleveland Museum of Art. 93: (B) Rosa Bonheur, *Recumbent Stag*. Watercolor and gouache over graphite on paper, 11" x 15" (28 x 38.1 cm). Cleveland Museum of Art. Photo of Rosa Bonheur ©Getty Images. 94: (A) John Singer Sargent, *Muddy Alligators*, 1917. Watercolor over graphite/off-white wove paper, 13 3/8" x 20 7/8" (34 x 53 cm). Worcester Art Museum. 95: (B) Melissa Miller, *Flood*, 1983. Oil on linen. Museum of Fine Art, Houston. 96: (A) Wanda Gag, *Cats at the Window*, 1929. Wood engraving, 29 1/8" x 38 1/8" (74 x 97 cm). Philadelphia Museum of Art. 97: (B) Okyo Maruyama, *Three Puppies*, 1790. Ink and colors on silk; mounted as a hanging scroll, painting: 15 1/4" x 18" (38.7 x 45.5 cm). Philadelphia Museum of Art. 98: (B) iStockphoto.com/Bill Raboin. 99: (B) Jimoh Buraimoh, *Insect*. Field Museum of Natural History. (C) iStockphoto.com/Katie Winegarden. (D) iStockphoto.com/Karla Caspari. 102: (A) André Derain, *Mountains at Collioure*, 1905. Oil on canvas, 32" x 39 1/2" (81.3 x 100.3 cm). ©2007 Board of Trustees, National Gallery of Art, Washington. André Derain Art © 2007 ARS, NY / ADAGP, Paris. 103: (B) George Hawley Hallowell, *Trees in Winter*, ca. 1910. Watercolor on paper, 21" x 15 3/8" (53.3 x 39 cm). Museum of Fine Arts, Boston. 104: (A) Elihu Vedder, *Cliffs of Volterra*, 1860. Oil on panel, 11 7/8" x 25 1/8" (30 x 64 cm). Butler Institute of American Art. 105: (B) Edward Hopper, *Hills, South Truro*, 1930. Oil on canvas, 27 3/8" x 43" (69.5 x 109.5 cm). Cleveland Museum of Art. 106: (B) iStockphoto.com/Warwick Lister-Kaye. 107: (A) Jean Metzinger, *Colorful Landscape with Aquatic Birds*. Musée d'Art Moderne de la Ville de Paris/Art Resource, NY. Jean Metzinger Art ©2007 ARS, NY/ADAGP, Paris. (C) iStockphoto.com/Alexander Hafemann. (D) iStockphoto.com/Francois Sachs. 110: (A) Nagasawa Rosetsu, *Bamboo*, eighteenth century. Ink on paper, six-fold screen, 50 3/4" x 102 13/16" (129 x 261 cm). Worcester Art Museum. 111: (B) Vincent van Gogh, *Haystacks*, 1888. Ink over graphite on paper, 9 3/8" x 12 1/8" (24 x 31 cm). Philadelphia Museum of Art. 112: (A, B) Carrie Nordlund, *Untitled, Seed Series*. Courtesy of the Artist. 114: (B) Betsy Begor pottery. Courtesy of Betsy Begor. 115: (A) Karita Coffey, *Plains Indian Women's Leggings*, 1981. White earthenware, 18" x 9" (46 x 23 cm). Courtesy of the artist. (C) Betsy Begor pottery. Courtesy of Betsy Begor. (D) Betsy Begor pottery. Courtesy of Betsy Begor. 118: (A) Early Middle Stone Age, *Bison Licking Its Back*, 15,000–10,000 BCE. Bone figure from La Madeleine, Dordogne, France. Musée des Antiquites Nationales, Saint-Germain-en-Laye, France/Art Resource, NY. 119: (B) Aboriginal bark painting, *Two Fish*. Ochre and natural pigments. Private Collection, Prague, Czech Republic/Art Resource, NY. (C) Getty Images. 120: (a) André Derain, *Mountains at Collioure*, 1905. Oil on canvas, 32" x 39 1/2" (81.3 x 100.3 cm). ©2007 Board of Trustees, National Gallery of Art, Washington. (b) George Hawley Hallowell, *Trees in Winter*, ca. 1910. Watercolor on paper, 21" x 15 3/8" (53.3 x 39 cm). Museum of Fine Arts, Boston. (c) Karita Coffey, *Plains Indian Women's Leggings*, 1981. White earthenware, 18" x 9" (46 x 23 cm). Courtesy of the artist. (d) Aboriginal bark painting, *Two Fish*. Ochre and natural pigments. Private Collection, Prague, Czech Republic/Art Resource, NY. (A) Robert Havell Jr., *Great White Heron*, 1831–38. Hand-colored lithograph on paper, 25 1/8" x 37" (64 x 94 cm). Butler

Institute of American Art. 121: (B) John J. Audubon, *The Blue Heron (Plate 217 from the Birds of America)*, 1827. Bibliotheque de l'Institut de France, Institut de France, Paris/Art Resource, NY. Photo of John James Audubon ©Bettmann/CORBIS.

Unit 5

122: (A) Helen Hardin, *Recurrence of Spiritual Elements*, 1973. Acrylic. Photo ©Cradoc Bagshaw 2007. 123: (B) Helen Hardin, *Deerslayers Dream*. 1981. Etching and aquatint on paper, 18" x 26" (46 x 66 cm). Photo ©Cradoc Bagshaw, 2007. 124: (A) Bette Nassar Clark, *Houses*, 1840–1860. Pieced cotton, 92" x 96" (233.7 x 243.8 cm). Courtesy of the artist. Photo ©Van Zandbergen Photography. Art Resource, NY. 125: (B) Jessie Harrison, *Mini Blue Sampler*, ca. 1994. Miniature quilt, 5 1/2" x 6 3/4" (14 x 17 cm). Courtesy of Jim Harrison. Photo ©Van Zandbergen Photography. 126: (A) Marilyn Diener, *Lilies of the Field*. Cut paper, 15 3/4" x 10" (40 x 25.4 cm). Courtesy of the artist. 128: (B) iStockphoto.com/Vera Bogaerts. 129: (A) Unknown, *Mola*. Nancy Walkup Collection. (C) iStockphoto.com/Martin Strmko. (D) iStockphoto.com/Myron Unrau. 132: (A) Asante people, *Three Kente Cloth Strips*, 1941–43. The Newark Museum. Art Resource, NY. (B) Asante people, *Kente Cloth, Silk*. 92 1/2" x 130 3/4" (235 x 332.1 cm). National Museum of African Art, Smithsonian Institution. 134: (A) Javanese, *Detail of the design on a batik sarong*, ca. 1920. Glazed cotton. Private Collection, Prague, Czech Republic. Photo credit: Werner Forman/Art Resource, NY. (B) Robin Paris, *Box Beetle*. Batik painting, 20 1/4" x 20 1/4" (51.43 x 51.43 cm). Courtesy of the artist. (C) Jane Maru, *Our Lady of Justice*, Batik painting. Courtesy of the artist. 136: (B) Getty Images. 137: (A) Mildred T. Johnstone with Pablo Burchard, *Alice in a Wonderland of Steel*, 1949. Linen plain weave with wool, angora, and metallic thread, 26" x 55 1/2" (66 x 141 cm). Allentown Art Museum. (C) Getty Images. (D) Getty Images. 140: (A) Javanese, *Wooden Wayang Shadow Puppet*, ca. 1800. Wood and paint. Private collection. Photo credit: Werner Forman/Art Resource, NY. (B) *Puppet from a Thai Buddhist drama*. Private collection, The Hague, The Netherlands. Photo credit: Werner Forman/Art Resource, NY. 142: (A) *Various Theatrical Masks*. Hellenistic influence. Terracotta. 600–500 BCE. Hermitage, St. Petersburg, Russia. Photo credit: Erich Lessing/Art Resource, NY. (B) Wendy Gough, *Contemporary Greek theater masks*. Courtesy of the Artist. 144: (B) ©Petr Mašek-FOTOLIA. 145: (C) iStockphoto.com/Ferenc Cegledi. (D) ©Matthew Kunz-FOTOLIA. 148: (A) Greek, *Mask of Dionysos*, 200–100 BCE. Terra-cotta, from Myrina. The Louvre, Paris. Photo credit: Réunion des Musées Nationaux/Art Resource, NY. 149: (B) Burkina Faso, *Bush Buffalo Mask*, early 1900s. Wood, cord, and fibers, 27 1/2" (69.8 cm) high. Cleveland Museum of Art (Gift of Katherine C. White). (C) ©Angelina Scully-FOTOLIA. 150: (b) Unknown, *Mola*. Nancy Walkup Collection. (c) Ashanti people, *Kente Cloth, Silk*. 92 1/2" x 130 3/4" (235 x 332.1 cm). National Museum of African Art, Smithsonian Institution. (d) Robin Paris, *Box Beetle*. Batik painting, 20 1/4" x 20 1/4" (51.43 x 51.43 cm). Courtesy of the artist. (A) Jeri Landers, *Grasshoppers of Hopalong Hollow*, 2005. Swiss paper cutting. From her children's book *Hopalong Jack and the Blue Bunnies*. Courtesy of the Artist. 151: (B) Keisuke Serizawa, *Mingei*, ca. 1950–1975. Hand-dyed stencil print on paper. Cleveland Museum of Art. Photo of Keisuke Serizawa courtesy of Shizuoka City.

Unit 6

152: (A) Elizabeth Murray, *Painter's Progress*, 1991. Oil on canvas in 19 parts, 116" x 93" (295 x 236 cm). The Museum of Modern Art, New York, NY. ©The Museum of Modern Art/Licensed by SCALA/Art Resource, NY. 153: (B) Elizabeth Murray, *Worm's Eye*, 2002. Oil on canvas, 8'1" x 7' 8" (246.4 x 233.7 cm). Private collection. ©Elizabeth Murray, courtesy PaceWildenstein, New York. Photo of Elizabeth Murray ©Getty Images. 154: (A) Pablo Picasso, *Baboon and Young*, 1951. Bronze, 20 7/8" x 13" x 20 7/8" (53 x 33 x 53 cm). The Museum of Modern Art, New York, NY. ©The Museum of Modern Art/ Licensed by SCALA/Art Resource, NY. ©2007 Succession Pablo Picasso/ARS, NY. (B) Murray Tinkelman, *Mechanimal: Diesel-Driven Guppy*, ca. 1979. Pen and ink on Arches paper, 24" x 12" (60.96 x 30.48 cm). Courtesy of the Artist. 155: (C) Wanda Gag, *Stone Crusher*, 1929. Lithograph, 14 3/8" x 11 3/8" (37 x 29 cm). Philadelphia Museum of Art. 156: (A) Patricia A. Renick, *Stegowagenvolkssaurus*, 1974. Steel and Fiberglas®, 12 x 7 x 20' (3.65 x 2.13 x 6.09 m)Courtesy of the Artist. (B) Patricia A. Renick, maquette for *Stegowagenvolkssaurus*. Courtesy of the Artist. 158: (B) iStockphoto.com/Stephanie DeLay. 159: (A) Leo Sewell, *Stegosaurus*. Sculpture, 14' x 7' x 20' (4.25 x 2.1 x 6 m). Courtesy of the artist. (C) iStockphoto.com/Marcelo Wain. (D) ©Loïc Michaud-FOTOLIA. 162: (A) Alfred Maurer, *Old Tree*, ca. 1924. Oil on canvas on cardboard, 30" x 19 7/8" (76.2 x 50.5 cm). The Phillips collection. (B) Georgia O'Keeffe, *Dark Tree Trunks*, 1946. Oil on canvas, 40 1/8" x 30" (102 x 76 cm). Brooklyn Museum of Art. 164: (A) Keisuke Serizawa, *Tree of Life*, ca. 1950–1975. Hand-dyed stencil print on paper. Cleveland Museum of Art. 165: (A) Patricia A. Renick, *Happy Town Tree*. Paper on clay, 27" (68.6 cm) tall. Courtesy of the artist and Shimmery Gallery. 166: (B) iStockphoto.com/Christine Balderas. 167: (A) Herbert Bayer, *The Tree*, 1931. Oil and collage, 18" x 15" (46 x 38 cm). Photograph Courtesy of the Artist. ©2007 Artists Rights Society (ARS), New York/VG Bild-Kunst. (D) iStockphoto.com/Vera Bogaerts. 170: (A) Elizabeth Murray, *Wiggle Manhattan*, 1992. Color lithograph on paper, 57 7/8" x 28 3/4" (147 x 73 cm). The Museum of Modern Art, New York, NY. ©The Museum of Modern Art/Licensed by SCALA/Art Resource, NY. ©Elizabeth Murray, courtesy PaceWildenstein, New York. (B) Piet Mondrian, *Broadway Boogie Woogie*, 1942–43. Oil on canvas, 50" (127 cm) square. The Museum of Modern Art, New York, NY. ©The Museum of Modern Art/Licensed by SCALA/Art Resource, NY. © 2007 Mondrian/Holtzman Trust c/o HCR International, Warrenton, VA. 172: (A) Amelia Peláez del Casal, *Fishes*, 1943. Oil on canvas, 27 1/4 x 33 1/2" (69.21 x 85.09 cm). The Museum of Modern Art, New York, NY. ©The Museum of Modern Art/Licensed by SCALA/Art Resource, NY. 173: (B) Gustave Caillebotte, *Fruit Displayed on a Stand*, ca. 1881–82. Oil on canvas, 30 1/8" x 39 5/8" (76.5 x 100.6 cm). Museum of Fine Arts, Boston. 174: (B) ©imagepro-FOTOLIA. 175: (A) Claes Oldenburg, *Two Giant Cheeseburgers with Everything*, 1962. Burlap soaked in plaster, enamel painted, 7" x 15" x 8.7" (18 x 38 x 22 cm). The Museum of Modern Art, New York, NY. ©The Museum of Modern Art/Licensed by SCALA/Art Resource, NY. (C) ©Andrey Chmelyov-FOTOLIA. (D) iStockphoto.com/Malcolm Romain. 178: (A) Annibale Carracci, *River Landscape*, ca. 1590. Oil on canvas, 46" x 69 1/8" (116.8 x 175.3 cm). ©2007 Board of Trustees, National Gallery of Art, Washington. 179: (B) Kano School, *Falcon on an Oak Tree Watching Monkeys*, 1596–1614. Ink and gouache on paper, 60 1/4" x 127" (153 x 322.4 cm). Worcester Art Museum. (C) iStockphoto.com/Franky De Meyer. 180: (a) Piet Mondrian, *Broadway Boogie Woogie*, 1942–43. Oil on canvas, 50" (127 cm) square. The Museum of Modern Art, New York, NY. ©The Museum of Modern Art/Licensed by SCALA/Art Resource, NY. © 2007 Mondrian/Holtzman Trust c/o HCR International, Warrenton, VA. (b) Gustave Caillebotte, *Fruit Displayed on a Stand*, ca. 1881–82. Oil on canvas, 30 1/8" x 39 5/8" (76.5 x 100.6 cm). Museum of Fine Arts, Boston. (c) Claes Oldenburg, *Two Giant Cheeseburgers with Everything*, 1962. Burlap soaked in plaster, enamel painted, 7" x 15" x 8.7" (18 x 38 x 22 cm). The Museum of Modern Art, New York, NY. ©The Museum of Modern Art/Licensed by SCALA/Art Resource, NY. (d) Amelia Peláez del Casal, *Fishes*, 1943. Oil on canvas, 27 1/4 x 33 1/2" (69.21 x 85.09 cm). The Museum of Modern Art, New York, NY. ©The Museum of Modern Art/Licensed by SCALA/Art Resource, NY. (A) Jackie Ferrara, *A211 Trannik*, 1980. Pine, 33" x 102 1/8" x 15" (83.8 x 259.6 x 38.1 cm). Worcester Art Museum. 181: (B) Dorothea Rockburne, *Guardian Angel II*, 1982. Watercolor on vellum, 755 1/8" x 53 1/8" (191 x 135 cm). The Museum of Modern Art, New York, NY. ©The Museum of Modern Art/Licensed by SCALA/Art Resource, NY. Photo of Dorothea Rockburne courtesy of Jinnine Pak

186: Margaret Burroughs, *The Folk Singer—Big Bill*, 1996. Linoleum cut, 17 3/8" x 21 1/8" (44.13 x 53.66 cm). Mary and Leigh Block Museum of Art, Northwestern University, Evanston, IL. Margaret Burroughs. 186: Martin Johnson Heade, *Giant Magnolias on a Blue Velvet Cloth*, ca. 1890. Oil on canvas, 15 1/8" x 24 1/4" (38.4 x 61.5 cm). Image ©2007 Board of Trustees, National Gallery of Art, Washington, DC (the Circle of the National Gallery of Art in Commemoration of its 10th Anniversary). 188: William H. Johnson, *Ferry Boat Trip*, ca.1943–1944. Oil on paperboard. 33 3/4" x 28 1/2". (85.7 x 72.4 cm). Smithsonian American Art Museum, Washington, DC. Smithsonian American Art Museum, Washington, DC/Art Resource, NY. 189: Paul Klee, *Castle and Sun*, 1928. Oil on canvas. Private collection, Great Britain. Erich Lessing/Art Resource, NY. Paul Klee Art ©2007 ARS, NY/VG Bild-Kunst, Bonn. Frank Gehry, Walt Disney Concert Hall, 2003. ©Rufus F. Folkks/CORBIS. Photo of Frank Gehry, AP Images.

Index

Acknowledgments

Program Contributors

Arganbright, Donna
Lafayette Elementary Schools
Walnut Creek, California

Beck, Cathy
Palisades High School
Kintnersville, Pennsylvania

Beck, Charles R.
Framingham State College
Framingham, Massachusetts

Chambers, Carol
Sangster Elementary School
Springfield, Virginia

Clark, Sylvia T.
Antelope Creek Elementary School
Rocklin, California

Cooney, Lil
Louise Archer Elementary School
Vienna, Virginia

David, Doris H.
Monroe Elementary School
Monroe, Connecticut

Diaz, Socorrito
Ruitort, Yanira
The Baldwin School of Puerto Rico
Guaynabo, Puerto Rico

Ellyn, Tracy
South Miami Elementary School
Miami, Florida

Johnson, Jeanne R.
Mechanicsburg School District
Mechanicsburg, Pennsylvania

Morrison, Mary
O'Regan, Betty
Rudinoff, Mark
Silverman, Nina
Twersky, Jonathan
Sanford School
Hockessin, Delaware

Silverstein, Barbara
Assumption School
Morristown, New Jersey

Wales, Andrew
Athens, Pennsylvania

Reviewers

Catherine M. Best
Art Teacher
St. Mary's Elementary School
St. John's, Newfoundland

Lillian Bussey
Art Teacher
Mount Pearl Secondary School
Mount Pearl, Newfoundland

Alexandra Coffee
Art Teacher
Claremont Math and Science
Academy
Chicago, Illinois

Ann Erickson
Leis Instructional Center
Falls Church, Virginia

Jaci Hanson
Art Education Consultant
Winter Haven, Florida

Mary D. Kehoe
Retired Art Teacher
Detroit Public Schools
Detroit, Michigan

Emma Lea Meyton
Art Education Consultant
Austin, Texas

Robin McDaniel
Art Teacher
Bates Academy,
Detroit Public Schools
Detroit, Michigan

Margaret Ryall
Educational Consultant
St. John's, Newfoundland

Ellen Varlas Culler
Art Specialist
Elm Grove and Bethlehem
Elementary Schools
Wheeling, West Virginia

Project Staff

President and Publisher
Wyatt Wade

Managing Editor
David Coen

Editor
Reba Libby

Consulting Editor
Claire Mowbray Golding

Reading and Language Arts Specialist
Barbara Place

Design
WGBH Design:
Tong-Mei Chan
Julie DiAngelis
Tyler Kemp-Benedict
Chrissy Kurpeski
Jonathan Rissmeyer
Douglass Scott

Production
Thompson Steele, Inc.

Editorial Assistants
Photo Acquisitions
Annette Cinelli
Mary Nicholson
Diane Carr

Illustrator
Susan Christy-Pallo

Photography
Tom Fiorelli

Manufacturing
Georgiana Rock